How to Paint and Draw

A complete step-by-step guide to techniques and materials

ANGELA GAIR

First published in 1999
by New Holland Publishers (UK) Ltd
London • Cape Town • Sydney • Auckland

24 Nutford Place
London W1H 6DQ
UK

80 McKenzie Street
Cape Town 8001
South Africa

3/2 Aquatic Drive
Frenchs Forest, NSW 2086
Australia

Unit 1A
218 Lake Road
Northcote
Auckland
New Zealand

10 9 8 7 6 5 4 3 2 1

ISBN 1 85974 147 9

Printed and bound in Malaysia by Times Offset (m) sdn Bhd

ACKNOWLEDGEMENTS
Special thanks are due to Winsor & Newton, Whitefriars Avenue, Harrow, Middlesex;
Daler-Rowney, Berkshire, RG12 4ST; Unison Colour, Thorneyburn, Tarset,
Northumberland and Canson & Montgolfier Papers, Unit 26, Stephenson Road, St. Ives,

CONTENTS

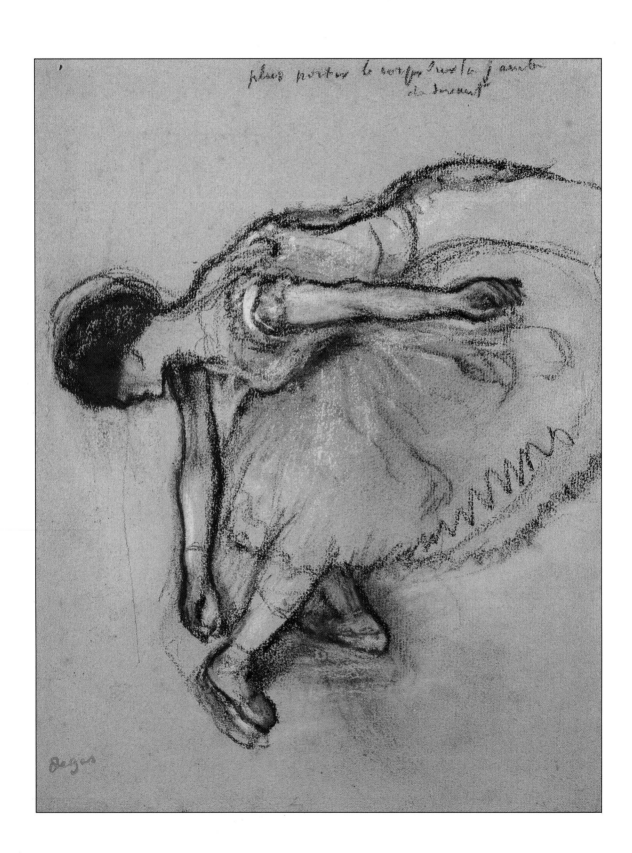

INTRODUCTION

Drawing is one of the most elementary of human activities. Its origins go back to the beginning of recorded history, when man began to depict hunting scenes on the walls of caves with charcoal outlines coloured with earth pigments. These pigments were mixed from natural earth colours - yellow and red ochres, and black made from carbon - and bound with animal fat and diluted with water - an early form of water-based paint.

The ancient Egyptians used pens made of sharpened reeds and inks made of powdered earth to draw hieroglyphics on sheets of papyrus. They also painted decorative reliefs on the walls of their palaces and tombs using water-based pigments.

It was not until the Greek classical period, in the fifth century BC, that artists began to make realistic representations of nature and to devise the classical concepts of proportion, space and volume that still have a strong influence on art in the present day. During the Middle Ages, when artists worked in the service of the Christian church, it was decreed that there should be no graven images, so realistic representation was once more replaced by stylized and symbolic

Dancer *Edgar Degas*

This pastel and charcoal study of a ballet dancer has an immediacy which captures the essence of a fleeting pose. The vigorous, sweeping strokes and the various visible alterations describe not only the grace and beauty of the dancer's stance but the general feeling of movement in her body. Charcoal and pastel are sympathetic drawing media, responding immediately to the artist's impulse.

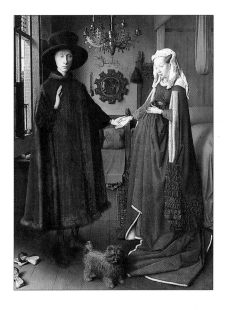

The Arnolfini Marriage *Jan van Eyck*

This tender portrait, painted in oils, of a couple plighting their troth is rich in symbolism. The candle flames are emblematic of the ardour of newlyweds; the dog is a symbol of marital faith; and the figure carved on the back of the chair is St Margaret, patron saint of childbirth. Each object is lovingly described with a subtlety and refinement that the oil medium allowed for the first time.

images. All this changed, however, with the flowering of the Renaissance between the fourteenth and sixteenth centuries. The term Renaissance means "rebirth", and the new era saw the narrow, superstitious beliefs of the Middle Ages give way to a resurgence of interest in the classical ideals of Greek and Roman art. Drawing became

established as the foundation of training in the arts.

Oil paints had been used since the twelfth century but it was the Flemish painter Jan van Eyck (c.1390-1441) whose techniques laid the foundations for the art of oil painting. The full potential of oil painting was not really exploited until it was taken up by Titian (1490-1576) and other Italian painters of the fifteenth and sixteenth centuries. The breadth of handling in Titian's later paintings at last revealed the medium's hitherto unleashed powers of expression and the fluency of technique was developed further by the Flemish painter Peter Paul Rubens (1577-1640) and arguably the greatest of all painters, Rembrandt (1606-1669).

Water-based paints had risen to prominence with the fresco paintings of the Renaissance artists in fifteenth- and sixteenth-century Florence. Fresco painting involved applying pigments mixed with water directly onto wet plaster. As the plaster dried, the colour was bonded into

Whaam! *Roy Lichtenstein (born 1923)*

This picture is painted using acrylics on two separate canvas panels and uses imagery derived from war comics. In some areas of the image Lichtenstein mimics the mechanical printing process of dot shading used in comic-book production; he placed a metal mesh screen on the canvas and brushed paint through the regularly-spaced holes with a toothbrush.

it and became part of the wall, instead of lying on the surface. The ceiling of the Sistine Chapel, painted by Michelangelo (1475-1564), is one of the largest and grandest frescoes ever painted.

By the time of the High Renaissance (late fifteenth and early sixteenth centuries) drawing had become looser in style and surface detail was suggested rather than rendered with precision. During the seventeenth century drawing at last became valued as a form of artistic expression in its own right rather than a mere adjunct to painting. The methodical use of hatched and cross-hatched lines to build up dark tones, used by the Renaissance artists, gave way to a new freedom and vigour of execution and a greater use of dramatic chiaroscuro (contrasts of light and dark).

France developed as the chief centre of artistic innovation during the eighteenth century. The invention of the graphite pencil helped to make drawing even more popular by enabling fine lines and shading to be achieved without the inconvenience of using ink. The French Impressionists of the 1860s and 1870s also had the greatest impact on the way that artists approach oil painting today. Monet (1840-1926), Renoir (1841-1919), Pissarro (1831-1903) and others tried to capture in their paintings the many moods and qualities of light and colour in the landscape as they experienced them directly in the open air.

Watercolour painting had become enormously popular and something of a British speciality, due in part to the emergence of "The Grand Tour". As

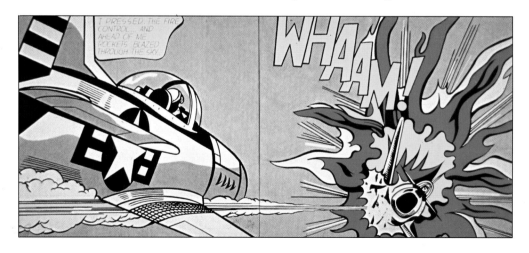

Britain grew more prosperous and outward-looking, it became fashionable for the sons of wealthy families to travel through continental Europe in order to broaden their education. These young tourists often took watercolour painters along with them to paint the classical ruins and picturesque scenes they visited.

The revolution of modern watercolour painting was largely inspired though by Paul Cézanne (1839-1906). Although loosely associated with the Impressionists, Cézanne was less interested in the ephemeral effects of nature than in its solidity and permanence. Believing that drawing and colour were inseparable, he interwove colour and line with one another for a unity of effect.

Pastels, as a medium, have a comparatively short history and it was in eighteenth-century France that some of their earliest and finest exponents worked. In the latter half of the century, there was a renewed emphasis on realism, naturalness and honesty in painting, as evidenced in the pastel work of the great French master, Jean-Baptiste Simeon Chardin (1699-1779). The pastel medium was developed far beyond the traditional formulae of the eighteenth-century masters by Edgar Degas (1834-1917). His reputation as the greatest pastelist of all time rests on his breathtakingly original compositions featuring dancers, café scenes and women washing or bathing; and his experimentation with the variety of strokes and his use of pastel and mixed media.

Acrylic paints developed as an indirect result of technological advances made in the plastics industry in the 1920s. These coloured pigments are essentially the same as those used in traditional media, but the vehicle is a transparent acrylic polymer. The paint dries in a matter of minutes, and once dry it forms a tough, flexible film that is insoluble in water and will not rot, discolour or crack, making acrylics an extraordinarily versatile medium. They can be used opaquely, like oils or gouache, or thinned with water to create effects identical to those of watercolour.

Despite the arrival of new media and the interaction and blurring of the distinction between painting and drawing, the most striking characteristic of twentieth-century art is its diversity of style and expression, encompassing both traditional and synthetic media.

The Waterfan *Winslow Homer (1836-1910)*

Homer is synonymous with the realist tradition of the flourishing watercolour movement in America in the late 19th century. In his seascapes and landscapes he recorded both the ethereal light of the tropical storms and the vibrant colour present on clear days.

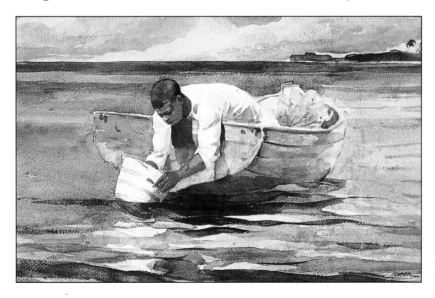

MATERIALS AND EQUIPMENT

There is an almost overwhelming variety of art materials available to the artist today. To save expense, it is advisable to start out with a few essentials and add extra colours, brushes and equipment as you gain more experience.

PENCILS

Graphite pencils are graded by the H and B systems, according to the relative hardness or softness of the graphite core. Hard pencils range from 9H (the hardest) to H. Soft pencils range

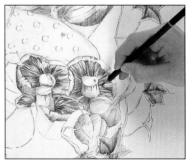

Pencils can be used to produce a quick study or to create a finely detailed drawing. Several pencils, in a range of soft and hard leads, were used to achieve the subtle tones in this still-life drawing.

from 8B (the softest) to B. HB is midway between hard and soft and is good for everyday use. A very soft lead enables you to make broad, soft lines, while hard leads are suited to fine lines and precise details. A medium grade such as 2B or 3B is probably the most popular for drawing.

CHARCOAL

Stick charcoal is made from vine or willow twigs charred in special kilns and is available in various thicknesses. Soft charcoal is powdery and smudges easily, so use with care and protect the finished work with spray fixative.

PASTELS

Pastels consist of finely ground pigments bound together with gum to form a stiff paste, which

is then shaped into sticks and allowed to harden. Four main types are available:

Soft pastels are the most widely used of the various types because they produce a wonderful velvety bloom. They contain more pigment and less binder, so the colours are vibrant. The smooth, thick quality of soft pastels produces rich, painterly effects. They are easy to apply, requiring little pressure to make a mark, and can be blended and smudged with a finger, rag or a paper stump (torchon).

Hard pastels contain less pigment and more binder than the soft type. Although they have a firmer consistency, the colours are less brilliant.

Pastel pencils are thin pastels that are encased in wood, like

ordinary pencils. They are clean to use, do not break or crumble and allow greater control of handling, perfect for line sketches and small-scale work.

Oil pastels are different in character from traditional pastels. The pigment and chalk are combined with an oil binder instead of gum, making the sticks stronger and harder. Oil pastels make thick, buttery strokes and their colours are clear and brilliant.

COLOURED PENCILS

An increasingly popular drawing medium, coloured pencils can be overlaid to create visual blending of colours. Water-soluble pencils are similar in appearance to ordinary coloured pencils, but the lead contains a water-sensitive binder. You can apply the colour dry and you can also use a soft watercolour brush dipped in water to blend colours together creating a wash-like effect.

INKS AND PENS

There are two types of drawing ink: water-soluble and water-proof. With water-soluble inks the drawn lines can be dissolved with water and the colours blended. With water-

A small selection from the wide range of papers available includes: 1 sugar (craft) paper; 2 and 6 cartridge (drawing) paper; 3 flour paper; 4 spiral-bound sketch book; 5 tinted watercolour paper; 7 vellum; and 8 Ingres pastel paper. An art folder (9) is useful for transporting drawings.

proof inks the lines remain intact and will not dissolve once dry, so that a wash or tint on top of the drawing may be added without spoiling the linework. Many types of drawing pen are available today, but the most popular are dip pens (a holder combined with a choice of nibs) and the fountain pen. Water-soluble ink should be used with all pens except dip pens to ensure that they do not clog.

PAPERS

Drawing paper is available in a wide range of weights, textures and colours, and can be purchased as single sheets, pads, sketchbooks or as boards which provide a firm support.

Choosing a paper

The texture of the paper, how rough or smooth it is, will affect the way you draw, so it is important to choose carefully. Machine-made papers are available in different finishes: "hot-pressed" (HP); "Not", meaning not hot-pressed (cold pressed); or "rough". Hot-pressed papers are smooth; Not papers have a medium texture, or "tooth"; and rough papers, as the name suggests, have a coarse texture.

The "weight" of a paper

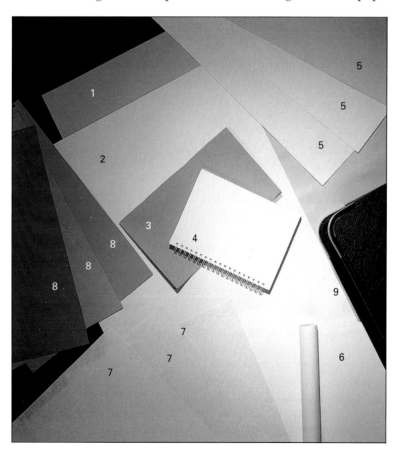

refers to its thickness and is measured in pounds (lb) per ream (480 sheets). Lightweight papers will buckle when wet washes of ink or paint are applied, so choose a good-quality, heavy paper.

Pencil Almost any type of surface can be used for pencil work. Generally, a smooth paper is most suitable for finely detailed drawing, and rougher surfaces for bold drawing. The water-soluble variety requires a heavy, watercolour-type paper to withstand wetting.

Pastel and charcoal Powdery materials such as pastel and charcoal need a support with enough surface texture to hold the particles of pigment. Smooth or shiny papers are unsuitable because the pastel or charcoal stick slides around and the marks are easily smudged. Canson, Ingres (charcoal), Fabriano and the inexpensive sugar (craft) papers are all good for charcoal and chalks. Pastel papers come in a range of surfaces: soft velour for blending colours smoothly and evenly; medium grain for general purposes; rough textures for lively, vigorous work and very fine grade flour paper which can hold dense layers of pastel and produce a strong, brilliant effect.

Pen and ink Bristol board has a very smooth, brilliant white surface and is ideal for pen and ink. It comes in different thicknesses, the lighter weights being more like a sturdy paper than a board. Smooth cartridge (drawing) paper is also suited to pen drawing, but brush and ink work well on a Not (cold-pressed) or rough surface, which breaks up the strokes and adds sparkle and vigour to the drawing.

Watercolour paints A wide variety of watercolour paper is available, both in single sheets and pads or blocks. The choice of paper will depend on the subject, the technique used and the effect required. "Hot-pressed" is very smooth, suitable for finely detailed work, but most artists find its surface too slippery for pure watercolour painting. "Not" is the most popular type of surface, and ideal for less experienced painters. Its medium-textured surface is good for large, smooth washes and fine brush detailing.

A selection of round and flat sable brushes in a range of sizes.

As a guide, the lightest watercolour paper is 70lb while a heavier grade is 140lb. Paper tends to warp or buckle when wet: the lighter the paper, the greater the warp. This problem is avoided by stretching it before use.

PAINTS

Watercolour paints are available in tubes of creamy paint and in small blocks of semi-moist colour called "pans". Tube colour is richer than pan colour and is useful for creating large areas of wash quickly; simply squeeze the paint onto the palette and mix it with water. Pans can be bought individually or in sets.

Acrylic paints are sold in tubes, jars and bottles with droppers. The type you choose depends on the consistency of paint you wish to work with. Tube paint is the thickest, paint in jars is more creamy and the bottled type is very fluid, ideal for covering large areas with intense, transparent washes. Oil paints are available in tubes only.

All paints are available in two different grades: artists' and students'. Artists' colours are of better quality and this is reflected in their price.

BRUSHES

Brushes are especially important to painting so it is worth buying good quality ones. Sable brushes are expensive, but they give the best results for all types of painting media. They are resilient, hold their shape well,

do not shed their hairs, and have a springiness which results in lively, yet controlled brush strokes. Bristle brushes, such as hog's hair brushes, are less expensive and versatile. Ideal for oil painting and acrylics, they are good for moving the paint around on the surface and for applying thick dabs of colour.

There are two basic shapes of brush: rounds for painting small areas and detail; and flats for applying broad washes. Rounds are bullet-shaped brushes that come to a fine point. By moving the broad side of the brush across the paper you can paint sweeping areas of colour, and with the tip you can paint fine details. Flats are wide and square-ended. They are ideal for spreading water rapidly over the paper to create a wash with watercolour paints and for blending, or for applying thick bold oil and acrylic paints. The square end is useful for fine lines and sharp detail.

Brushes are graded according to size, ranging from as little as 0000 to as large as 14. Three or four brushes are enough to start with; choose a small round for fine detail, a large flat for laying washes and a medium-sized round and flat for general work.

Brush Care

Look after your brushes and they will last a long time. Wash brushes with warm water and mild soap (after using oils — rinse your brush first in white spirit then soap and water). Shake out excess water, form brushes to their original shape and then lay them flat or place them head-upwards in a jar to dry.

SUPPORTS

Watercolour paper is discussed earlier. For oils and acrylics the most popular surface is canvas which is usually made of linen, jute or cotton duck, and is available in either fine, medium or coarse-grained weaves. For bold heavy brush strokes, a coarse weave is best, and for detailed brushwork and soft blending, a finely woven texture is more suitable. Supports for oil painting, whether canvas, board or paper, must be prepared with glue size and/or primer to prevent them absorbing the oil in the paint, and the paint cracking. Acrylic paints can be applied to any surface that is oil- and grease-free and slightly absorbent.

MEDIUMS

Oils and acrylics can be mixed with a dilutent to add texture and body to the paint. Ready-mixed painting mediums are available, designed variously to improve the flow of paint, thicken it for impasto work, speed its drying rate, and produce a matt or a gloss finish. Further information on using mediums and dilutents can be found on pages 82 and 99.

ACCESSORIES

Erasers Plastic or kneaded putty erasers are best, being very malleable without damaging the surface of the paper. Use them on soft graphite, charcoal or pastel drawings, both to erase and to create highlights.
Knives and sharpeners A sharp craft knife/scalpel for sharpening pencils and cutting paper is essential.
Fixative For pastels, chalk, charcoal or soft graphite pencil, preserve your drawings by spraying them with fixative. This can be bought in aerosol spray form or as a mouth-type atomizer.

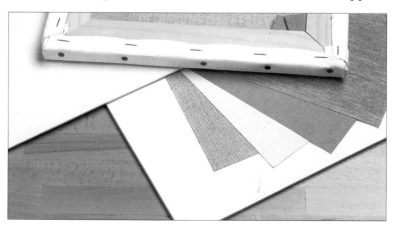

Supports for oil painting and acrylics must be properly prepared with size/primer before use.

DRAWING
BASIC TECHNIQUES

MAKING MARKS

The first step in drawing is to discover the potential expressive range of your chosen medium by experimenting with the marks it can make. Start by making random marks on scrap paper – scribbling, hatching and rubbing until the drawing instrument seems to be an extension of your hand.

Pencil

The immediacy and sensitivity of pencils make them the most popular tool for drawing. The character of a pencil line is influenced by the grade of pencil used, the pressure applied, the speed with which the line is drawn, and the type of paper used. Soft pencils are good for rapid sketching and encourage a bold, gestural style of drawing. Hard pencils make fine, incisive lines and are better suited to detailed representational drawing. Tonal effects are achieved by means of hatched and crosshatched lines; by varying the density of the lines, fine gradations in tone from light to dark can be created.

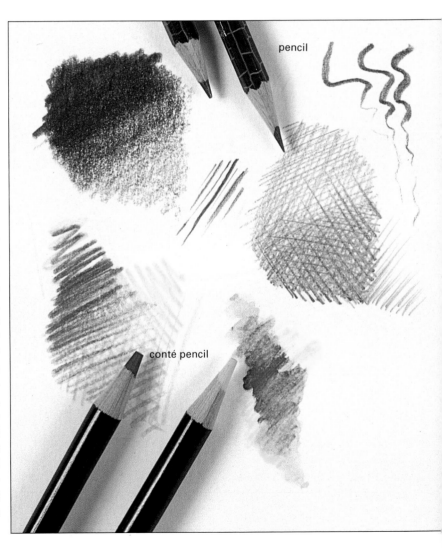

pencil

conté pencil

Charcoal

Charcoal is a uniquely expressive medium with a delightful "feel" to it as it glides across the paper. With only a slight variation in pressure on the stick a wide range of effects is possible, from delicate hatching to strong and vigorous marks. Because charcoal smudges so easily it can also be rubbed and blended for rich tonal effects, and highlights can be picked out with a kneaded putty eraser. Charcoal is messy to handle, and it is advisable to use spray fixative to prevent unwanted smudging.

Pastel and Crayon

Pastels, chalks and crayons are extremely versatile in that they can be both a drawing and a painting medium. By twisting and turning the stick, using the tip and the side, it is possible to obtain both expressive lines and broad "washes" of colour.

Soft pastels and chalks, being powdery, can be blended easily to create a delicate veil of colour, but a more lively effect is gained by combining blended areas with open linear work. The density of colour is controlled by the amount of pressure applied; with strong pressure you can achieve the density of oil paint, and this effect can be contrasted with strokes that pass lightly over the surface.

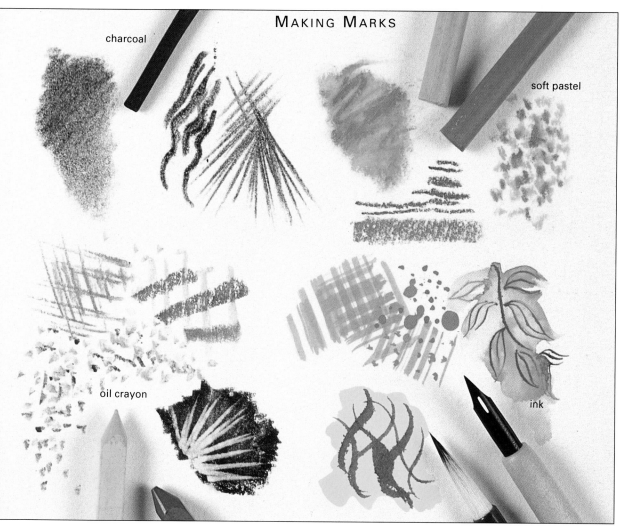

MAKING MARKS

charcoal

soft pastel

oil crayon

ink

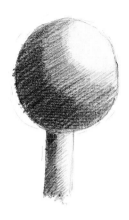

All forms can be broken down into basic geometric shapes - the sphere, cylinder, cone or cube - practise modelling these forms with light and shade.

Pastels which are thinly applied or loose on the surface can best be erased by using a stiff-bristled paintbrush to flick away the powdery colour. Conventional rubber erasers tend to smear the pastel into the grain instead of lifting it off. A kneaded or putty eraser can be useful for lightening a small area to obtain a highlight.

Pastel and charcoal paintings can be protected from smudging by spraying with fixative. Tap the board first to dislodge the loose particles of pigment and then spray with a fine mist of fixative.

Ink

Whether it is bold and dynamic or delicate and lacy, ink drawing has a striking impact. Tones must be rendered with lines or marks, overlapping or varying the spacing to create degrees of light and dark. Ink can also be applied with a soft brush to create a completely different range of marks, and washes can be laid down using diluted ink.

Form and Volume

The way light and shadow fall on objects helps to describe their solid, three-dimensional form. In drawing and painting, solidity and the illusion of a third dimension is suggested by using tonal values - degrees of light and dark.

The best approach is to ignore distracting detail and simplify what you see, breaking the subject down into basic areas of light and shade. These simplified areas are called "planes". The lightest planes are those areas that receive direct light; the darkest are those furthest from the light source. Once you have established the basic form and structure of your subject by simplifying it into planes of light and shade, you will find it easier to develop detail and refine the drawing by breaking up these major planes into smaller, more complex and subtle ones.

PROPORTIONS OF THE FIGURE

Most artists gauge the proportions of the figure by taking the head as their unit of measurement. Generally speaking, the head of a standing adult fits into the total height of the figure about seven times. This is a useful guide, but remember that no two people are built exactly alike or carry themselves in the same way, and there is no substitute for sensitive observation of the actual subject.

A common mistake in drawing figures is to make the arms too short and the hands too small. When the arms are relaxed, the tips of the fingers hang a considerable way down the thighs, and the hands measure almost one head unit.

Seated Figures

When drawing a seated figure, use the proportions of the chair as a guide. Within this frame, mark off the position of various points of the body – shoulders, hips, thighs, knees – in relation to the back, seat and legs of the chair. Foreshortening of the legs, particularly if they are crossed, can be difficult to represent convincingly. The tendency is to draw what we know, not what we see; it is vital to look repeatedly at your model, to check that angles and proportions are correct, and, most of all, to trust what your eyes tell you.

A useful tip is to regard the figure as a two-dimensional shape and draw its outline as accurately as you can.

In the average adult human, the length of the head from crown to chin represents one-seventh of the total height of the figure.

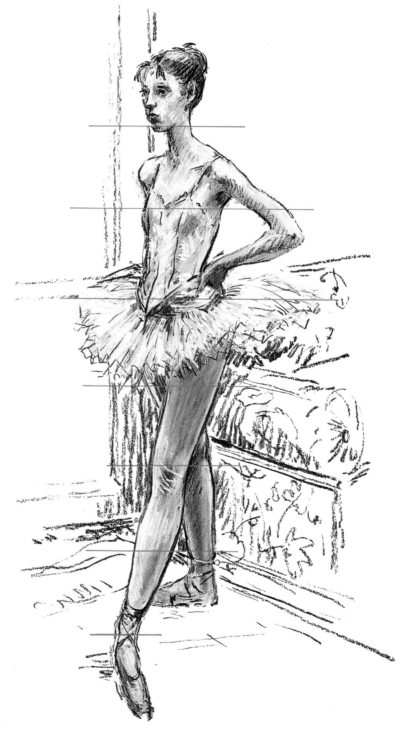

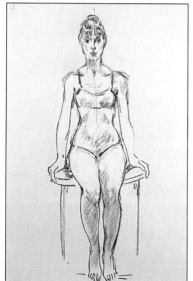

In a seated figure, the thighs appear foreshortened. Observe the model closely and draw what you see, not what you know.

LINEAR PERSPECTIVE

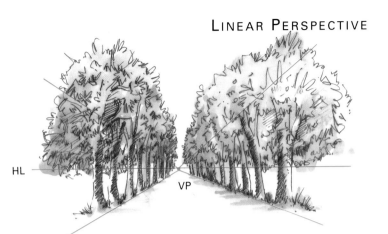

HL VP

ONE-POINT PERSPECTIVE
When you stand in the middle of a road, hallway or room, all parallel horizontal lines appear to converge at a single point on the horizon (HL), known as the vanishing point (VP).

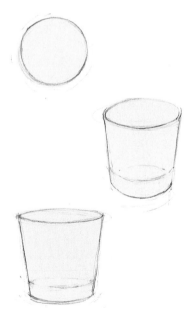

VP

VP

VP

VP

VP

TWO-POINT PERSPECTIVE
When you view a building from one corner, the horizontal lines of each wall again appear to converge at the horizon, and each set of lines has its own vanishing point (VP).

LINEAR PERSPECTIVE

Perspective is a useful set of principles which help the artist to create a convincing illusion of three-dimensional depth and space on a flat, two-dimensional piece of paper.

The principle of linear perspective is that all parallel lines on the same plane (for example the edges of a long, straight road) appear to get closer together as they recede into the distance. The point at which they appear to meet is called the "vanishing point". The vanishing point is always on the horizon line, and the horizon line always corresponds to

your eye level. The vanishing point gives you an exact method for determining the angle of every receding line in your picture, thus ensuring that your drawings are accurate and true. This is the simplest form of perspective, known as one-point perspective.

If two sides of an object are visible – as when you are facing the corner of a building –

Hold a glass in your hand so that you are looking directly onto it. Slowly tip the glass away from you and observe how the circular rim flattens out into an ellipse. The further you tip the glass, the narrower the ellipse.

16

two vanishing points are necessary. The lines forming the top and bottom edges of both sides appear to converge and meet on the horizon, each with its own vanishing point.

SPHERES AND ELLIPSES

When drawing a still-life subject, you will inevitably be faced with the problem of depicting bottles, glasses, jugs, cups and other cylindrical or spherical shapes in perspective. This task may seem daunting at first, but it becomes much easier if you understand how perspective works.

A circular shape such as the rim of a glass, when viewed from an oblique angle, flattens out and becomes an ellipse. To demonstrate this, hold a glass in front of you and look straight down on it. You will see that the rim forms a perfect circle and the sides of the glass are not visible. Now slowly tip the glass away from you: observe how the further you tip the glass, the narrower the circle becomes and the sides of the glass come into view.

When drawing rounded objects, draw them as if they were transparent in order to get a sense of their three-dimensional shape. You can then erase the parts that are not actually visible. Use light pressure, filing out the form with flowing, continuous strokes. Lines drawn with too much pressure often look awkward and uneven, and unwanted lines are difficult to erase.

SQUARING UP

You may wish to base a drawing on a sketch or a photographic image; but it is often difficult to maintain the accuracy of a drawing when enlarging or reducing a reference source to the size of your working paper. A simple method of transferring an image in a different scale is by squaring up (sometimes called scaling up).

Using a pencil and ruler, draw a grid of equal-sized squares over the sketch or photograph. The more complex the image, the more squares you should draw. If you wish to avoid marking the original, make a photocopy of it and draw the grid onto this. Alternatively, draw the grid onto a sheet of clear acetate placed over the original, using a felt-tip pen.

Then construct an enlarged version of the grid on the working sheet, using light pencil lines. This grid must have the same number of squares as the smaller one. The size of the squares will depend on the degree of enlargement required: for example, if you are doubling the size of your reference material, make the squares twice the size of the squares on the original reference.

When the grid is complete, transfer the image that appears in each square of the original to its equivalent square on the working sheet. The larger squares on the working sheet serve to enlarge the image. You are, in effect, breaking down a large-scale problem into smaller, manageable areas.

1 Draw a grid of squares onto a sheet of tracing paper laid over the reference sketch.

2 Lightly draw a grid of larger squares onto the drawing paper and transfer the detail from the reference sketch, square by square.

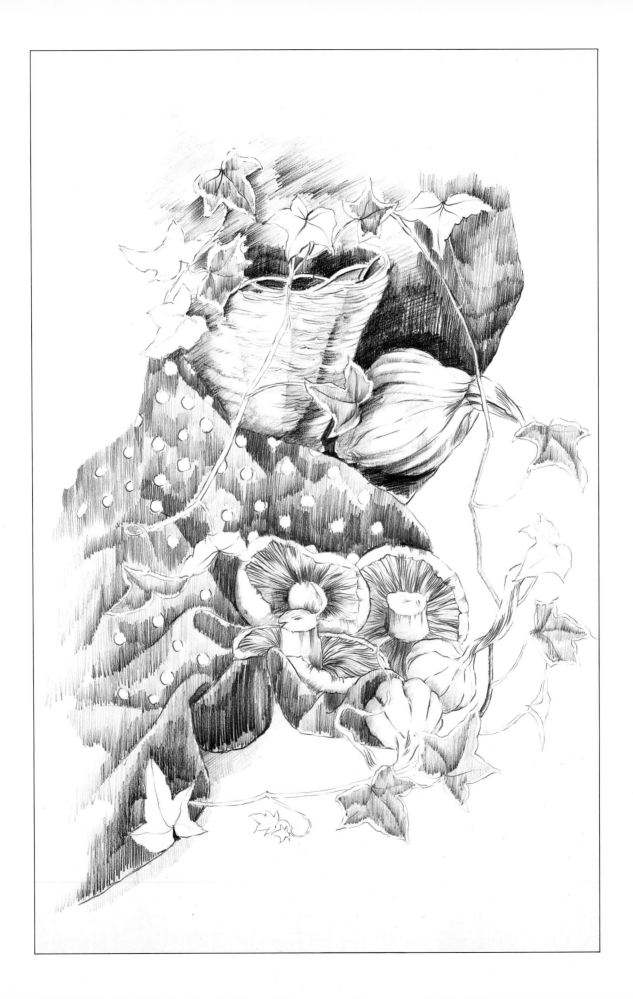

HATCHING AND CROSSHATCHING

Artists today have an enormous variety of drawing materials and techniques at their disposal. Yet somehow a simple, finely wrought pencil drawing has a timeless appeal which has never been surpassed.

This still-life study employs the classical techniques associated with monochrome media such as pencil and pen and ink. Using a system of hatching and crosshatching, the artist has built up a carefully modulated network of fine lines to establish the dark, medium and light tones and suggest the contours of the objects. Variety is achieved by altering the direction of the strokes and by using a combination of hard, medium and soft-grade pencils.

As in watercolour painting, the white of the paper plays an essential part in a pencil drawing. Here small areas of untouched paper indicate the lightest highlights, and the artist has deliberately faded out the tones at the edges of the drawing to create a softly "vignetted" effect.

~

Annie Wood
Still Life with Ivy
58 x 41cm (23 x 16in)

~

HATCHING AND CROSSHATCHING TECHNIQUE

Hatching and crosshatching have been used for centuries as a means of creating form and texture in a monochrome drawing. In hatching, the lines run parallel to one another; in crosshatching, they cross each other at an angle to create a fine mesh of tone. Simply by varying the number of lines and the distance between the lines, it is possible to obtain a tremendous range of tones, varying from very light to extremely dark. But because the white of the paper is not completely obliterated, the tone retains a luminosity that is one of the assets of this technique. The lines themselves can also convey energy and movement, particularly when they run in different directions, following the contours of the subject and describing its form and volume.

The effect achieved will be determined by the type of pencil used (hard or soft) and its point, by the type of paper, by the degree of pressure applied and by the character of the lines, whether tightly controlled or free and sketchy. In this project drawing, for example, the artist has worked on a hot-pressed cartridge (drawing) paper, its smooth surface making the fine pencil lines appear crisp and clean.

This technique is time-consuming and requires a patient, methodical approach, but it is very satisfying. It is important to build up the lines gradually until you achieve the depth of tone you require. Too much deepening of tone too early can make the finished drawing overly dark and heavy, so be patient when building up the shadows. It is essential with this type of shaded drawing to refer constantly to the subject, looking carefully at the shadows and judging each tone in relation to its neighbour. Try to develop the drawing as a whole, gradually bringing the tones in various parts of the composition into line with each other as you work.

Before attempting the following project, practise drawing series of lines close together to create a range of darks, lights and mid-tones. Use a sharp pencil and smooth paper. When you have mastered this, practise varying the pressure, angle and direction of the strokes.

In crosshatching, subtle and intricate colour harmonies can be obtained by interweaving strokes of different colours.

STILL LIFE WITH IVY

Right: The objects in this still life were chosen for their interesting contrasts of texture, tone and pattern. The wicker basket was raised up on a pile of books, hidden by a cloth, so as to emphasize the graceful lines of the trailing ivy.

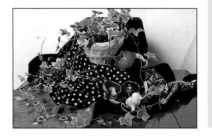

Materials and Equipment

• SHEET OF SMOOTH-SURFACED CARTRIDGE (DRAWING) PAPER • GRAPHITE PENCILS: GRADES HB, 3H, 2H, B AND 2B • SOFT KNEADED PUTTY ERASER • CRAFT KNIFE • SANDPAPER BLOCK

1

Start by making sure all your pencils are sharpened to a fine point. Working on a sheet of cartridge (drawing) paper, lightly sketch the main outlines of the objects using an HB pencil.

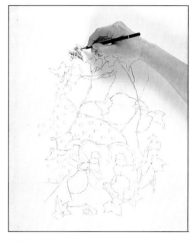

2

Once you are satisfied with the composition, use a 3H pencil to tighten up and darken the outlines. Begin shading the dark patterning on the ivy leaves with parallel hatched strokes.

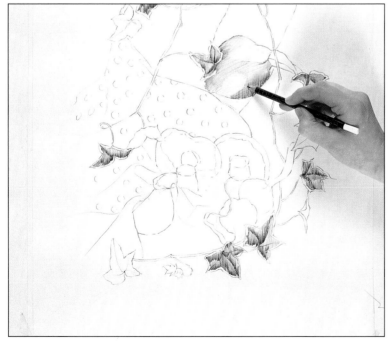

3

Continue building up the mid-tones with diagonal hatched strokes, using a 2H pencil for the lightest areas and a B pencil for the darker ones. Work on the onion with lightly hatched strokes of a 2H pencil. Strengthen the shadow at the base of the onion with crosshatched strokes of a B pencil.

DRAWING: HATCHING AND CROSSHATCHING

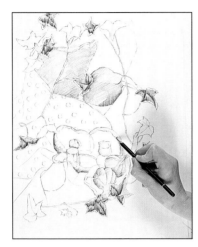

4

Lightly shade in the basket containing the pot of ivy with a 2H pencil. Then work on the lightest parts of the mushrooms and the garlic bulbs. Continue working all around the drawing so that you can judge the relative tones of neighbouring objects. Gradually you will see the contours emerge from the complex pattern of lights and darks.

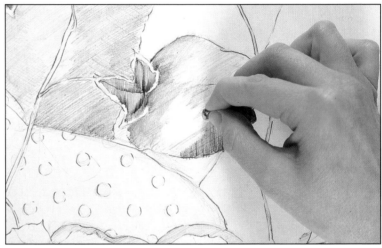

5

Use a kneaded putty eraser, formed into a point, to lift out soft highlights such as those on the onion.

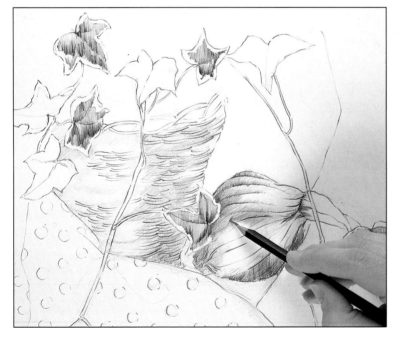

6

With a 2H pencil, suggest the texture of the wicker basket with dark, curved strokes, working on top of the lighter hatching. Draw the lines on the papery onion skin and begin working up the darker tones with further hatched strokes.

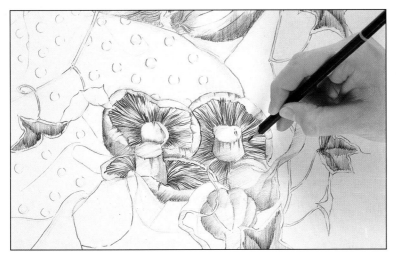

7

Draw the dark gills of the mushrooms with strong lines using a 2H pencil.

8

Indicate the form of the foreground drapery with vertical hatched strokes, using a B pencil for the lighter tones and a 2B for the darker ones. Vary the density of the lines and leave areas of paper untouched for the highlights and the white polka dots.

Fill in the dark backcloth with a 2B pencil. Lay down closely spaced parallel lines, working first in one direction and then going over them in another, until the required density of tone is achieved.

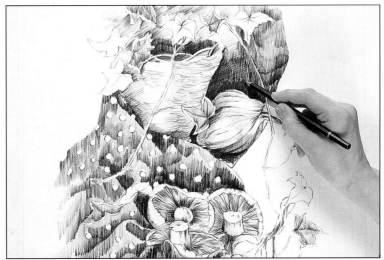

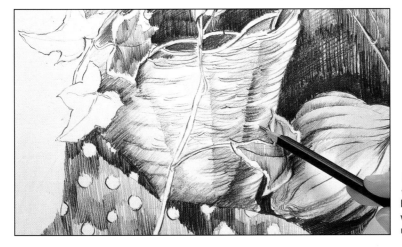

9

Finally, add further texture to the wicker basket with curved strokes using a 2B pencil.

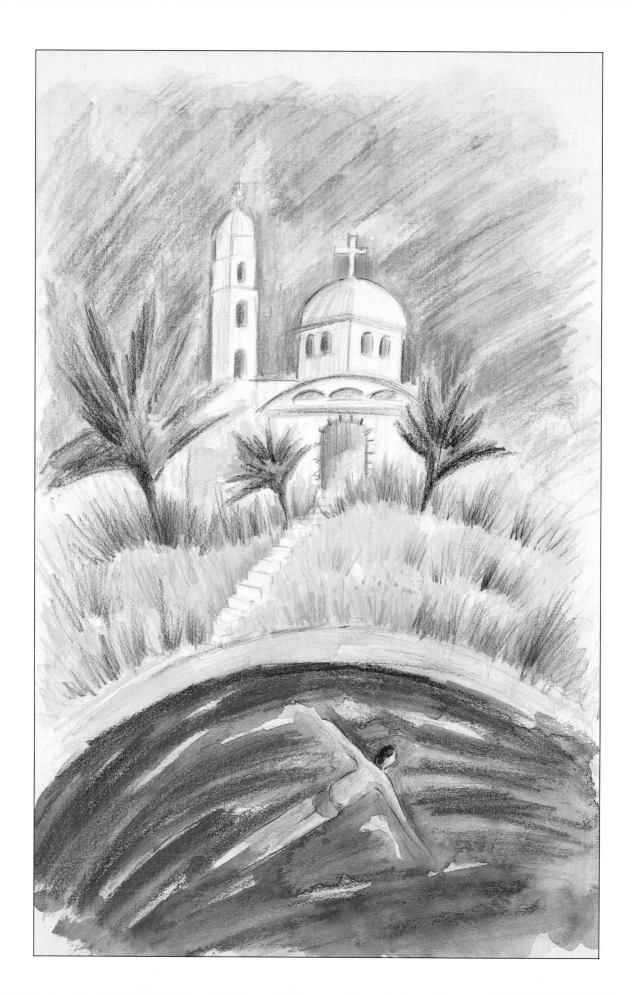

USING WATER-SOLUBLE PENCILS

There is a wide range of coloured pencils and crayons on the market, and in recent years this medium has become increasingly popular with fine artists as well as graphic designers. Water-soluble pencils, which can be used as both a drawing and a painting medium, are clean, quick and portable, and ideal for outdoor sketching.

In keeping with the Mediterranean subject, this water-soluble pencil drawing of a garden in Greece plays sunshine yellows against clear blues to produce a vibrant effect. Multi-layered washes and strokes are used to develop form and texture.

Annie Wood
The Pool
48 x 33cm (19 x 13in)

HOW TO USE WATER-SOLUBLE PENCILS

Water-soluble pencils are a cross between coloured pencils and water-colour paints. You can apply the colour dry, as you would with an ordinary coloured pencil, and you can also use a soft watercolour brush dipped in water to loosen the pigment particles and create a subtle water-colour effect. When the washes dry, you can then add further colour and linear detail using the pencils dry again. This facility for producing tightly controlled work and loose washes makes water-soluble pencils very flexible.

After lightly applying the required colours with hatched strokes, work over the colours with a soft brush and a little clean water to blend some of the strokes and produce a smoother texture. (This takes a little practice; if you use too much water the paint surface will become flooded and blotchy; too little will not allow for sufficient blending of the colours.) The water will completely dissolve light pencil strokes, blending the colour until it looks similar to a watercolour wash. Heavy pencil strokes will persist and show through the wash.

Apply the water gently – do not scrub at the paper with the brush as you want to keep the colours fresh and bright. Rinse the brush every now and then to make sure you are working with clean water, otherwise the colours may become tainted.

Interesting textures can be created by building up the picture with multiple layers of dry pigment and water-dissolved colour. When adding dry colour over a dissolved base, however, the paper must first be completely dry; if it is still damp, it will moisten the pencil point and produce a blurred line, and it may even tear.

Suitable surfaces for water-soluble pencil work are either a smooth illustration board, or a good-quality watercolour paper or medium-grain drawing paper, which should be stretched and taped to a board first.

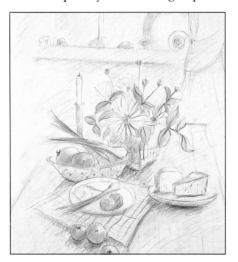

Water-soluble pencils have a freshness and delicacy that is ideally suited to a subject such as this still life, softly lit by the morning sun.

THE POOL

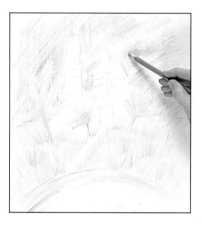

1

Lightly indicate the main elements of the composition with a soft pencil. Fill in the sky area with loosely hatched diagonal strokes of pale blue pencil, leaving some of the white paper showing through. Work lightly to avoid making any hard line. Use a warm yellow pencil for the palm trees and grasses, using upward flicking strokes.

Materials and Equipment
• SHEET OF 300GSM (140LB) NOT (COLD-PRESSED) SURFACE WATERCOLOUR PAPER, STRETCHED • SOFT PENCIL • WATER-SOLUBLE COLOURED PENCILS: PALE BLUE, WARM YELLOW, DARK BLUE, LIGHT GREEN, DARK GREEN, PINK, PURPLE, ORANGE, LIGHT OCHRE, VIOLET, BLUE-GREEN AND DARK BROWN • MEDIUM-SIZED ROUND WATERCOLOUR BRUSH

2

Suggest the water in the pool with light strokes of pale blue, again leaving plenty of white paper showing through. Vary the direction of the strokes to suggest the movement on the water's surface created by the swimming figure.

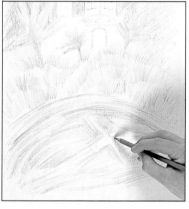

3

Load a medium-sized round brush with water and work it lightly over the sky area to soften and partially blend the pencil lines. Use sweeping, diagonal strokes to give a sense of movement to the sky.

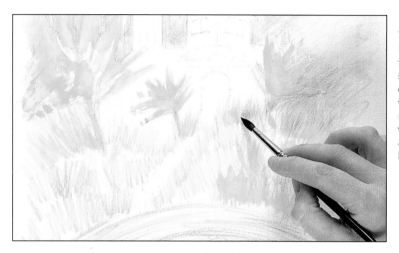

4

Rinse your brush, then apply water to the trees and grasses to blend some of the pencil strokes and create a smoother texture. Don't worry if some of the yellow wash runs into the sky area – it will mix with the blue and form green, giving a suggestion of more foliage in the background. Leave to dry.

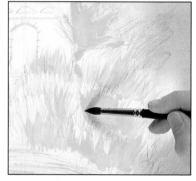

5

When applying the water, work lightly across the drawn lines without rubbing too hard. This releases just enough colour to produce a light wash which does not completely obliterate the linear pencil strokes.

6

Work back into the sky with further diagonal hatched strokes of both pale and dark blue, leaving some areas of wash untouched. With the dark blue pencil, firm up the water with vigorous directional strokes that follow the curved form of the pool. Leave some patches of pale blue to indicate the highlights on the water's surface.

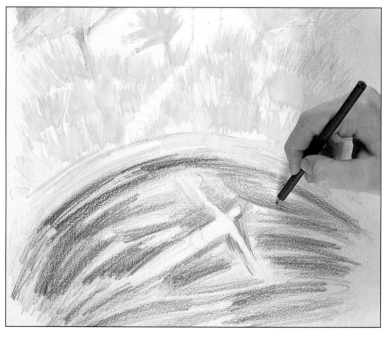

7

Work into the trees and grasses with short, upward flicking strokes of light and dark green. Also add touches of pink, purple and orange to add colour interest and give a suggestion of heat and bright sunlight. Block in the figure's skin tone with a light ochre pencil, and his swimming trunks with pink. Add further washes of water to pick up and dissolve some of the colour in the pool.

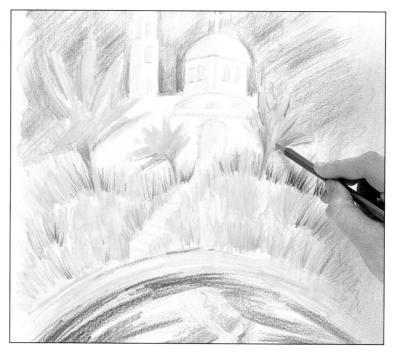

8

Add strokes of dark green to the palm trees and grass. Strengthen the detail on the church, blocking in the door, the windows and the shadows on the walls with strokes of pink and yellow. Then darken the door and windows with overlaid strokes of dark blue and violet.

9

Darken the water with broad strokes of blue-green, wetting some of the strokes to create a sense of movement on the water's surface. Leave to dry, then block in the swimmer's hair with dark brown. Finally, strengthen the outline of the figure with a dark blue pencil.

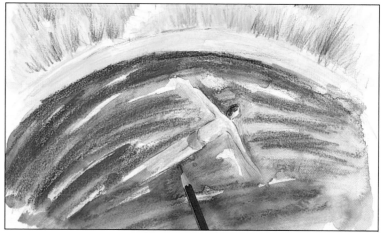

DRAWING ON TINTED PAPER

A drawing done in pastel or conté crayon on tinted paper is very much a marriage of medium and paper. Because areas of the tinted paper show through the drawn marks they play a key role in the overall colour scheme; thus the paper and the drawn lines work in tandem, creating an exciting fusion of texture and colour.

This study of a head in profile was drawn in conté crayon on a warm buff-coloured paper. The paper creates the mid-tones, while the form of the head and shoulders is modelled with hatched strokes, using earth colours for the darks and white for the highlights. Because the paper itself acts as the mid-tone for the skin and hair, the artist needs only a few colours to build up a fully developed portrait.

~

Elizabeth Moore
Head Study
51 x 33cm (20 x 13in)

~

USING TINTED PAPERS

There are two ways in which a tinted paper surface can function in a drawing. The first is as a mid-tone, from which the artist can assess extremes of light and shade. The second is as a unifying element, its colour linking the various areas of the composition to form a unified image.

Drawing papers come in such a wide range of colours that it can be difficult to choose the best one for your needs. Start by deciding whether you want the paper's colour to harmonize with the subject or to provide a contrast. Then decide whether the colour should be cool, warm or neutral. For example, artists often favour a paper with a warm earth colour to accentuate the cool greens of a landscape, or a neutral grey paper to enhance the bright colours of a floral still life. Finally, decide whether you want a light, medium or dark-toned paper. In general, mid-toned papers give the best results. They allow you to judge both the light and dark tones in your drawing accurately, and they provide a quiet, harmonious back-drop to most colours. It is generally best to avoid strongly coloured papers since they will fight with the colours in the drawing. If you are in any doubt, choose muted colours such as greys, greens and browns.

Conté crayons are similar in effect to charcoal but they are harder and therefore can be used for rendering fine lines as well as broad tonal areas. Although conté crayons are now available in a wide range of colours, many artists still favour the restrained harmony of the traditional combination of black, white and the three earth colours – sepia, sanguine and bistre. These colours, with their warm, tender and soft tones, are especially suited to portrait and figure drawings. Expressive lines can be drawn with the crayon point while varied tones are possible using the side of the crayon, thus providing an exceptional way of suggesting form, light, colour and volume. The traditional colours also give an antique look reminiscent of the chalk drawings of Leonardo da Vinci, Michelangelo, Rubens and Claude.

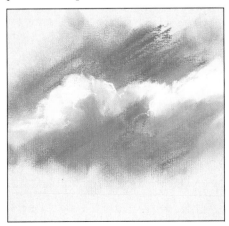

This cloud study is worked in chalk on tinted paper. The paper forms a useful mid-tone from which to work up to the lights and down to the darks.

HEAD STUDY

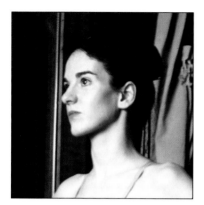

Left: Strong directional light coming from the left of the model helps to describe the volumes of the head.

<div>

Materials and Equipment
• SHEET OF BEIGE CANSON PAPER • CONTÉ CRAYONS: SEPIA, INDIAN RED, WHITE, RAW UMBER AND BLACK • SPRAY FIXATIVE

</div>

1

Using the sepia crayon, start by sketching the main outlines of the head and positioning the features. Use light, feathery strokes so that you can build up the darker tones later without clogging the surface of the paper.

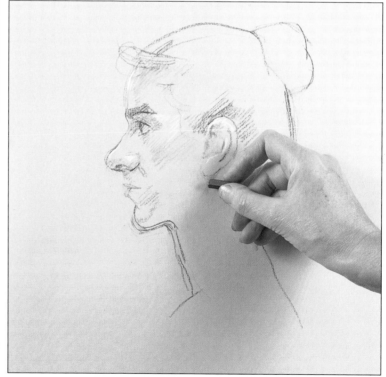

2

Continue to define the head and features and the line of the neck and shoulders. To establish the main planes of the face, begin shading in the darkest tones with light hatching, using the sepia crayon. Indicate the mouth and cheeks with Indian red.

3

Continue defining the tones and colours on the face with sepia and Indian red. Indicate the highlights on the forehead, upper cheek and chin with white. Use stronger tones of sepia and Indian red to model the inner ear. Build up the shadowed areas of the hair with overlapping strokes of sepia, allowing the buff paper to show through. This shading helps to define the underlying form of the head. Hatch in the shadow on the neck.

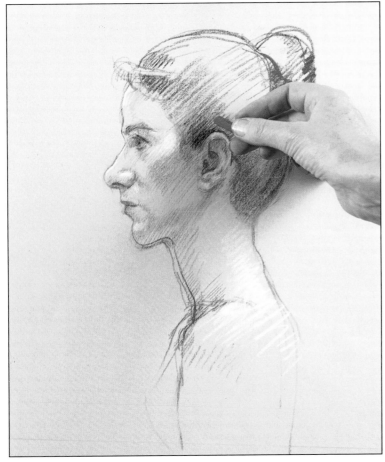

4

Strengthen the modelling on the face and neck with fine hatching to produce carefully graded tones. Use sepia, raw umber and Indian red for the shadows and white for the highlights. As you draw, constantly relate shapes and volumes to one another rather than drawing one part in detail and then moving on to the next. Use stronger tones of sepia and Indian red to model the inner ear, and solid strokes of white for the highlights. Darken the hair with strokes of black.

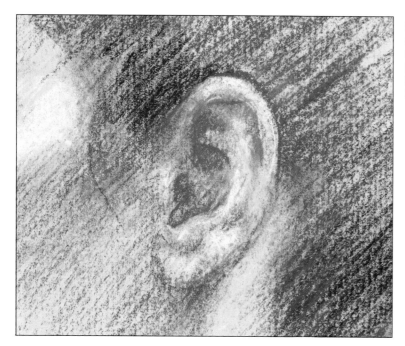

Left: The whorls and curves of the ear are quite complex, but the trick is to render them as simply as possible, paying close attention to the shapes of the shadows and highlights.

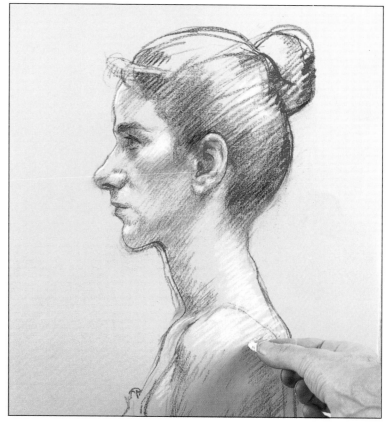

5

Briefly sketch in the shadows and highlights on the neck and shoulders with sepia and white. The head is more fully modelled as this is the focal point of the picture.

Observe how the tinted paper shows through the drawing in places, suggesting the mid-tone between dark and light. These patches of bare paper also help to breathe air into the drawing, enhancing the delicacy of the drawn lines. Because conté smudges easily, the finished picture should be sprayed lightly with fixative.

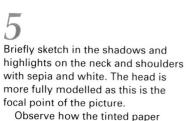

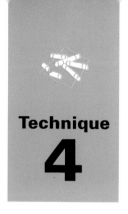

Technique
4

BLENDING

Soft pastels, being powdery, can be smudged and blended very easily to create a range of subtle textures and effects; for example, when suggesting the soft, amorphous nature of skies, water and soft foliage, and in recreating the effects of space, distance and atmosphere.

Blending can give pastel work a sensuous subtlety, but when overdone it creates a slick, "sugary" surface that robs the painting of all character. As a rule of thumb, it is best to retain the textural qualities of the pastel and the surface as much as possible and to use blending selectively and in combination with other, more linear, strokes for contrast.

In this skyscape, the artist did a certain amount of blending with her fingers and with tissues, but most of the soft gradation in the clouds is accomplished by using the pastels on their sides and drifting one colour over another. The surface tooth of the paper breaks up the strokes and forces one to merge with the next, but the colours retain their freshness because they are not degraded by too much rubbing.

Jackie Simmonds
Skyscape
33 x 51cm (13 x 20in)

BLENDING TECHNIQUE

The simplest means of blending consists of laying a patch of solid pastel colour, using the tip or the side of the stick, and fading it gently outward with your finger to create soft tonal gradations. Similarly, two adjoining colours can be blended together where they meet to achieve a gradual colour transition, and two overlaid colours can be blended to create a solid third colour.

The finger is perhaps the most sensitive blending "tool", but depending on the effect you want to achieve, you can use a rag, paper tissue, brush or torchon (a pencil-shaped tube of tightly rolled paper). Use your finger to blend and intensify an area of colour; rags, tissues and brushes to blend large areas and to soften and lift off colour; and a torchon for precise details.

Blending is a very seductive technique, but when overdone it can rob the colours of their freshness and bloom (this bloom is caused by light reflecting off the tiny granules of pigment clinging to the surface of the paper). You don't always have to rub or blend the colours; if you use the pastels on their sides you will find that the gradual overlaying of strokes causes them to merge where required without muddying. A light, unblended application of one colour over another is more vibrant and exciting than a flat area of colour.

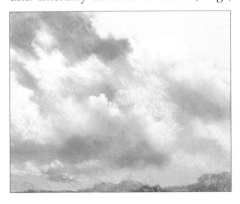

It is important to provide visual contrast by integrating blended areas with other, more vigorous pastel strokes. Here, for example, grainy, scumbled strokes give definition to the edges of the clouds.

SKYSCAPE

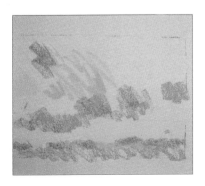

1

With a subject such as a sky, it is best to avoid drawing any outlines, as this could inhibit the freedom of your drawing. Simply plot the main elements of the sky and land using light, scribbled strokes of red-brown, blue-grey, blue-purple and cobalt blue, applied with the sides of the pastels.

Materials and Equipment

• SHEET OF WARM GREY CANSON PAPER • SOFT PASTELS: RED-BROWN, PALE CREAMY YELLOW, PALE ORANGE, BLUE-PURPLE, COBALT BLUE, BLUE-GREY AND LIGHT BLUE-GREY • SOFT TISSUES

2

Use a piece of crumpled soft tissue to soften and blend the pastel marks and remove any excess pastel particles. In effect, you are making a loose underpainting that will enhance the colours you apply on top.

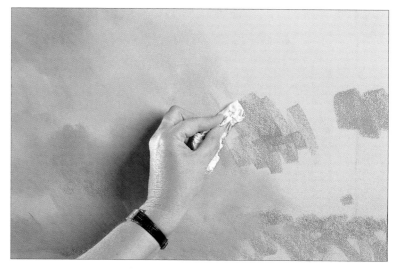

3

With the blue-purple pastel, put in the hills on the distant horizon using side strokes applied with a little more pressure. Start to develop the dark undersides of the cumulus clouds with the same colour, adjusting the pressure on the pastel stick to create denser marks in places. Use your fingers to soften and blur the clouds, dragging the colour downwards to create a sense of movement.

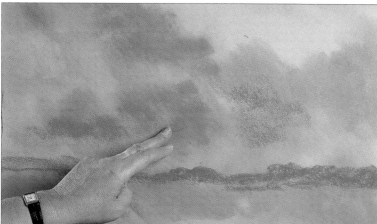

4

Use blue-purple to put in the smaller, flatter clouds near the horizon. This will help to create the illusion of space and recession. Now use a light blue-grey pastel to block in the mid-tones in the clouds, using the same technique used earlier to create the soft, vapourous effect of rain clouds. Adjust the tones by varying the pressure on your fingers as you blend the strokes.

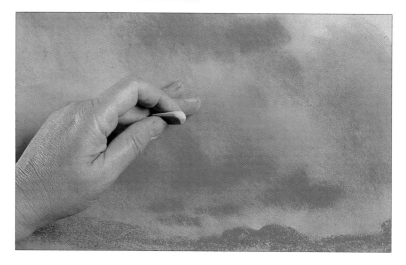

5

Now illuminate the lighter parts of the clouds, and the yellowish tinge of the sky at upper right using a very light tint of creamy yellow. Apply gentle pressure with the side of the pastel stick to float the colour over the grey underlayers.

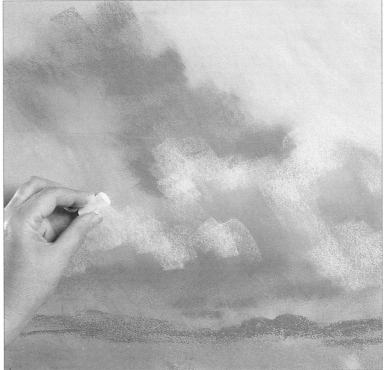

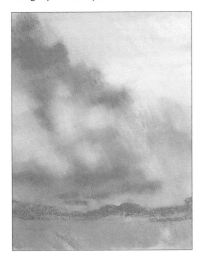

6

Softly blend the creamy yellow tones with your fingers, again using downward strokes. Build up subtle colours in the sky on the right, layering on strokes of pale blue-grey at the top and pale orange along the horizon. Blend a little with your fingers, but leave some of the strokes untouched so that the warm tone of the paper shows through the overlaid colours and enhances the glow of the evening sky.

7

Define the sharp, sunlit top edge of the cloud using fairly firm pressure with the tip of the creamy yellow pastel. Then use the same colour to build up the forms of the sunlit tops of the cumulus clouds with small scumbled strokes made by pressing the side of the pastel to the paper and then feathering it away to create soft-edged marks.

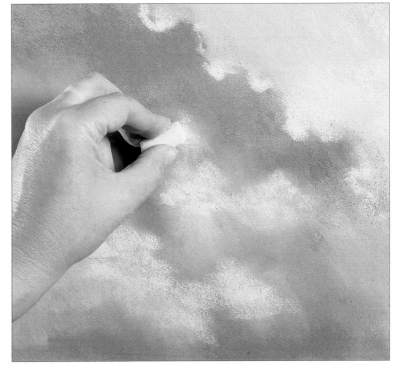

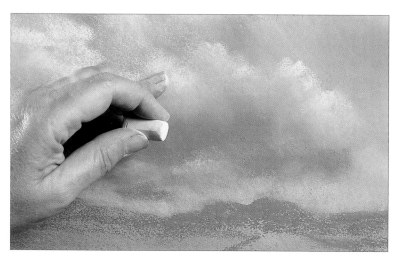

8

Build up three-dimensional form in the sunlit clouds by scumbling their top edges and then gently blending the colour downwards with your fingertip as shown, leaving the top edge unblended. The blended strokes create the translucent, airy effect of rain clouds, while the scumbled edges give form and definition, preventing the clouds becoming too "woolly".

9

As your picture develops, step back from it at intervals to assess the overall effect. Continue to develop the forms within the towering bank of storm cloud, using the tip and side of the creamy yellow pastel to create blended tones and feathered strokes that give the three-dimensional effect of some clouds floating in front of others.

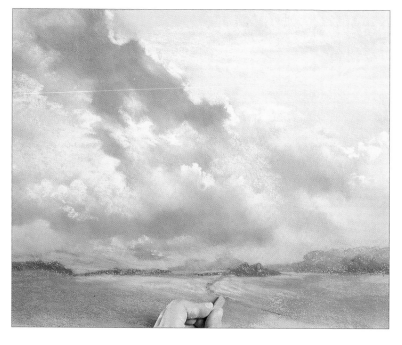

10

Finish the picture by suggesting the forms of the landscape. Go over the distant hills with light blue-grey to push them back in space, then draw in the trees and hedges with the darker blue-grey. For the foreground field, use red-brown modified with overlaid strokes of blue-grey and creamy yellow to suggest patches of light and shadows cast by the clouds. Repeating similar colours in the sky and the land also helps to unify the composition. Use the blue-grey pastel to suggest a curving track through the field that leads the eye into the picture.

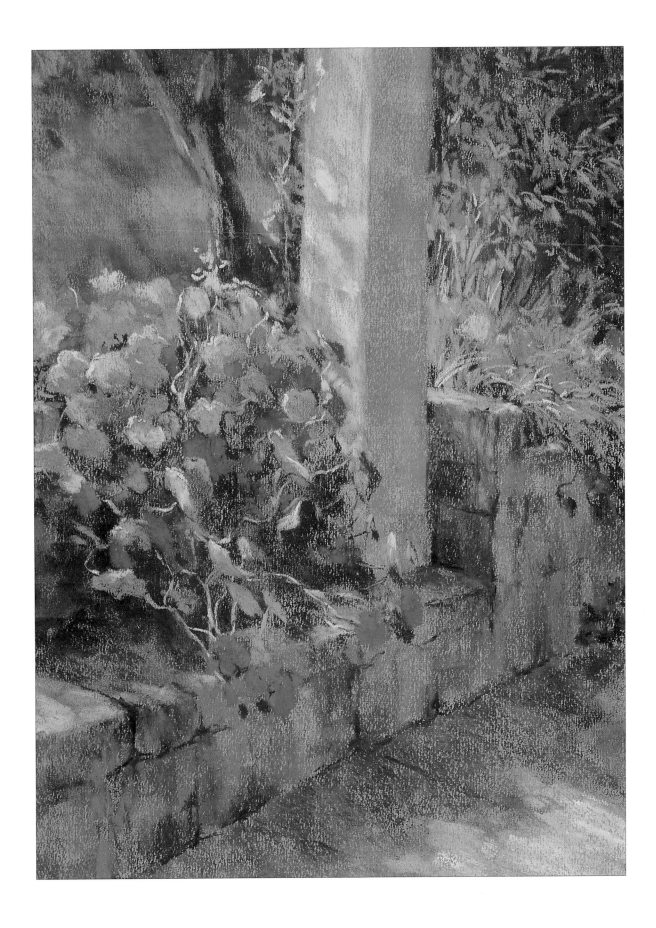

OVERLAYING COLOUR

This painting reflects the artist's delight in recreating the effects of light on the landscape. Bright sunlight filters down through the trees, casting dappled patterns on the cool, shadowy patio and brightly illuminating a flower here, a leaf there. A rich and exciting surface is achieved through the combined techniques of blocking in broad colour areas with the side of the pastel and drawing into shapes with the pastel tip.

Although the composition itself is quite simple, there is a lot of texture and detail in the flowers and foliage – subjects that can all too easily become overworked and muddy. In order to make sense of the complex mass of flowers, grasses and foliage, the artist began by blocking in the composition with thin layers of colour applied with the side of the pastel. From this initial "underpainting" she was able gradually to work up detail and intensify colour, creating the impression of massed foliage without clogging the paper surface.

Jackie Simmonds
Sunlit Patio
51 x 41cm (20 x 16in)

BUILDING UP THE PAINTING

Whereas an aqueous medium such as watercolour sinks into the body of the paper, dry, powdery pastel pigment more or less sits on the surface. If you apply too many heavy layers of colour, especially in the early stages, the tooth of the paper quickly becomes clogged and the pigment eventually builds up to a solid, slippery surface that resists further applications of colour.

To avoid this, you need to pace yourself in the early stages – it is a mistake to try to get to the finished picture too soon. A successful method of building up a pastel painting is to start by rapidly laying in the broad shapes and colour masses of the composition with thin colour before starting to develop the detail. Snap off a short length of pastel and block in the main colour areas, using side strokes to apply broad patches of grainy colour. These initial layers should be lightweight and open-textured; work lightly and loosely, stroking the colour on in thin veils and leaving plenty of paper showing between the strokes.

Overlaying thin, loose strokes of pigment in this way allows you to build up tones and colours gradually, without overworking the surface, so that when you come to accentuate the detail with linear marks and thicker colour towards the end of the picture, the colours will remain fresh and the strokes distinct.

It is important to keep the surface of the picture light and open in the early stages, to avoid clogging the paper with pigment and making the surface unworkable.

SUNLIT PATIO

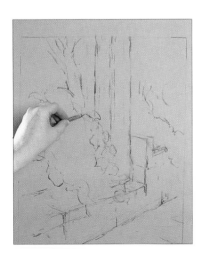

1
Sketch in the main outlines of the composition using charcoal. Draw with a light touch, keeping the lines loose and sketchy so that you can easily brush them off if you need to make alterations.

Materials and Equipment

• SHEET OF MEDIUM-TONED GREY FABRIANO PASTEL PAPER • THICK PASTEL STICKS: WARM RED, BRILLIANT RED, COOL RED, BRIGHT, GREENISH YELLOW, DARK GREEN, A RANGE OF LIGHT, WARM GREENS, DARK BLUE, DARK, MEDIUM- AND LIGHT-TONED UMBERS AND OCHRES, LIGHT TINT OF WARM OCHRE, BLUE-GREY, LIGHT TONE OF TURQUOISE GREEN • STICK OF CHARCOAL • SPRAY FIXATIVE

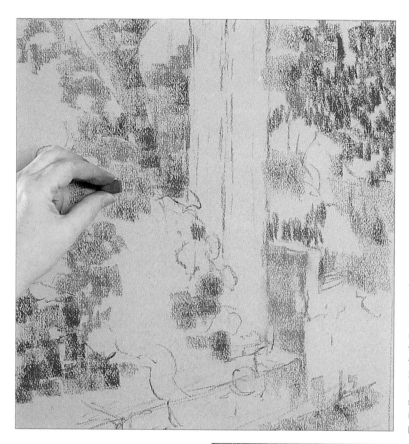

2

Rough in the main areas of light and dark tone, using a range of dark blues, greens and earth colours to establish the dark colour values of the background tree and foliage and the shadows in the foreground. Snap off short lengths of pastel and lightly stroke the colour on with the side of the stick, using short, broken marks that allow the colour of the paper to show through.

3

Using the same technique, block in the stone column and wall in the foreground using a light tint of warm ochre. Indicate the shadows on the column with a light tint of blue-grey, gently breaking it over the underlying colour with light, feathery strokes, allowing the warm ochre to show through and suggest the "glowing" effect of reflected light bouncing back into the shadows.

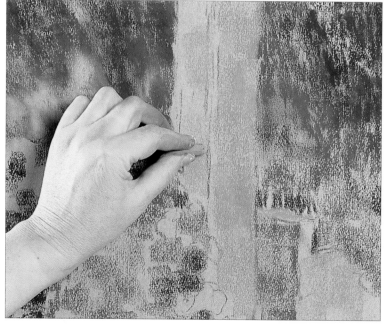

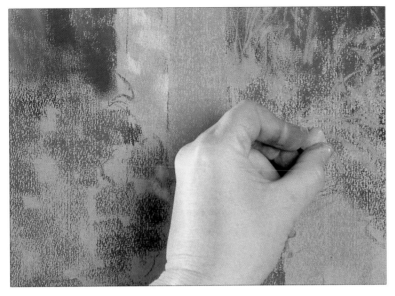

4

Apply broken strokes of very light ochre to indicate patches of dappled sunshine on the column. Now that the lights, darks and mid-tones are established, you can begin to build up the image with more colour and detail. Suggest the sunlit leaves and grasses in the background using a light, warm green. This time use the chisel edge of the stick to make linear strokes of varying lengths, and in various directions, to suggest leaves, tendrils and stalks.

5

Use the same green to paint the nasturtium leaves tumbling over the wall, using a short length of pastel on its side to make broad blocks of colour suggesting the fat, rounded forms of the leaves.

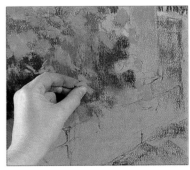

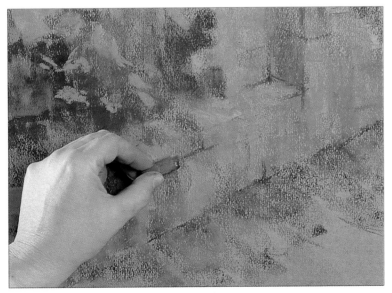

6

Before developing the nasturtiums any further, build up colour and texture on the wall using a mid-toned yellow ochre and a darker tone of burnt umber. Lay the colours over each other with broad side strokes in a vertical direction to indicate blocks of stone. Lay some of this colour over the cast shadow below the wall, too. Indicate a few fissures in the rock using the chisel edge of a dark blue pastel. Don't overdo it – just one or two broken, linear marks is all you need to suggest the crumbling texture of the wall.

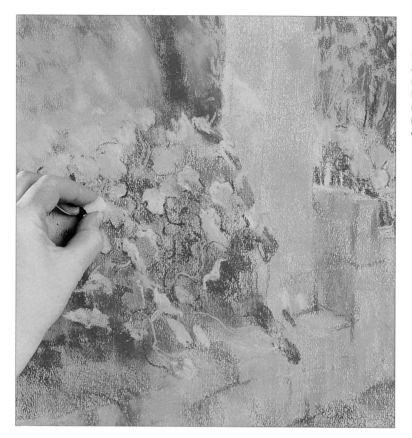

7

Using the same dark blue, pick out and define the edges of some of the nasturtium leaves, then block in the lightest tones on the sunlit leaves using a light tint of turquoise-green. Lightly spray-fix the picture so that you can add further layers of colour.

8

For the nasturtium flowers you will need two reds: a bright, warm one for the nearer blooms, and a slightly cooler, bluer one for those further back. Draw the flowers with scribbled strokes, suggesting their shapes rather than defining them too clearly and losing the spontaneity of the image. Vary the shape and size of the flowers, making them larger in the foreground and gradually getting smaller farther back.

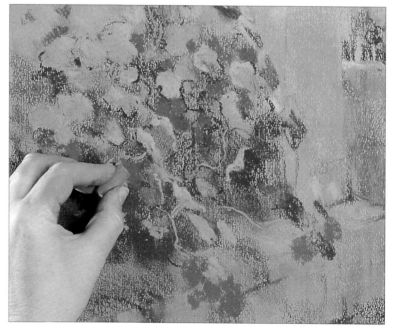

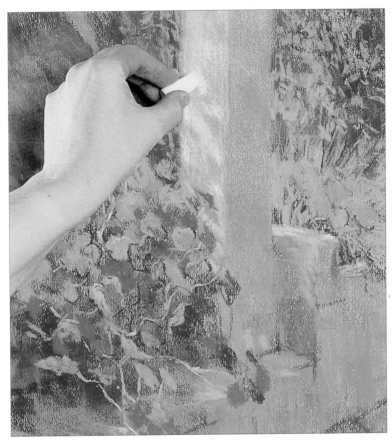

9

Use a warm, yellowish green to draw the sunlit tendrils and stalks of the nasturtiums with light, broken lines. Then add more dappled highlights on the column and the top of the wall using a very light tint of ochre. Apply a little more pressure with the pastel stick now, to give the highlights more definition. Stroke some of the same colour onto the road in the immediate foreground.

10

Deepen the shadows on the wall and road with side strokes of bluish grey applied with a light touch so that the underlying colours glow through. Then add the brightest highlights on the flowers, using a brilliant poppy red. Don't be tempted to overdo these highlights, though – brilliant spots of colour are more effective when used sparingly.

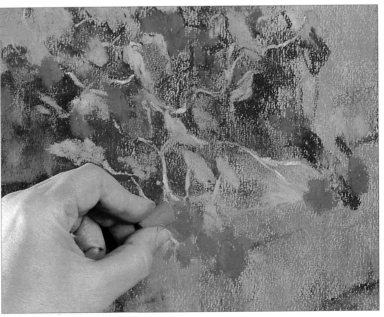

11

Develop the background, applying strokes of warm ochre on the sunlit side of the tree and suggesting the shifting patterns of light and shadow on the grass using a warm yellow green and a cool turquoise green. Gently blend the colours with the tip of your finger; these broad masses, in contrast with the sharper detail in the foreground, help to increase the illusion of space and depth in the picture.

Use a light greenish yellow to draw the creeper twining up the column and to accent the light-struck leaves and tendrils, mainly along the top edge of the flowers but also where the sun catches here and there near the bottom of the wall.

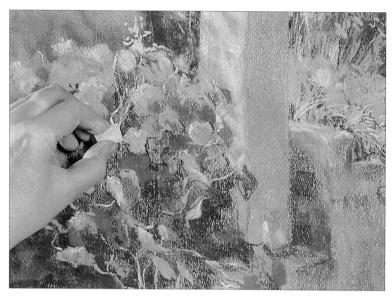

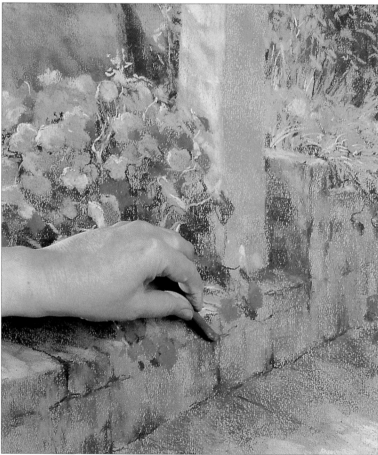

12

Finally, suggest the crumbling texture of the wall using a thin charcoal stick to lightly draw in a few cracks and fissures.

WATERCOLOURS
BASIC TECHNIQUES

MIXING PAINT

You can use almost any non-absorbent white surface as a palette for watercolour paint; in fact, when mixing a wide range of colours you may find an old white china plate gives you more room than a standard watercolour palette.

Watercolour paint always dries lighter on the paper than it appears when wet, so mixing is often a matter of trial and errror. It is impossible to tell by looking at the paint on a palette whether the colour or shade is right: the colour must be seen on the paper. Therefore, when mixing, you should always have a spare piece of the selected paper ready for testing the colours before committing them to the actual painting.

Always mix more paint than you think you will need; it is surprising how quickly it is used up. This applies particularly to watercolour washes, which need a lot of paint; it is frustrating to run out of colour half-way through an expansive sky wash, for example. And if you run out of a particular mixed colour, you may find it

If you find a certain colour mixture successful for a particular subject, keep a note of it for future reference. This test piece provides a useful visual record of the tones and colours used for the various elements of a painting — helpful if you run out of a colour and have to mix more to match the shade.

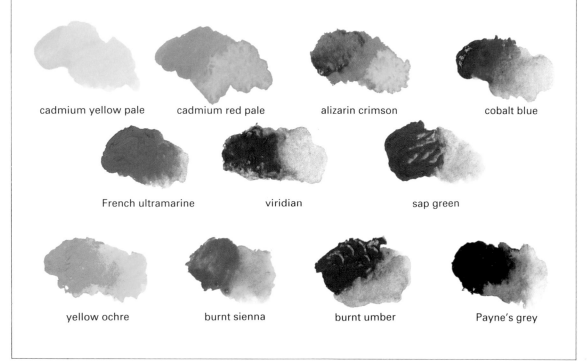

SUGGESTED PALETTE

Cadmium yellow pale
A strong bright warm yellow, very useful in mixes. When mixed with viridian it produces soft, warm greens.

Cadmium red pale
A warm, intense red. Produces good pinks and purples when mixed with other colours.

Alizarin crimson
A cool, slightly bluish red; diluted it creates delicate pinks. Mixed with ultramarine, it produces a pure violet.

Cobalt blue
Gentler and more subtle than French ultramarine, it is wonderful for skies.

French ultramarine
A dark, subdued blue with a faint hint of violet. Mixes well with yellow to form a rich variety of greens and with brown to form interesting greys.

Viridian
This deep, rich green retains its brilliance, even in mixes. Ideal for cooling reds, it also mixes well with burnt sienna to create a useful shadow colour.

Sap green
A lovely, resonant green that provides a wide range of natural greens and browns in mixes — ideal for landscape colours.

Yellow ochre
A soft yellow, very useful in landscape painting. Produces soft, subtle greens when mixed with blues.

Burnt sienna
A gentle, dark and transparent brown. Mixes well with other pigments to create muted, subtle colours.

Burnt umber
A rich and versatile brown, ideal for darkening colours.

Payne's grey
Made from a mixture of blue and black, this is a good all-round colour. In mixes, it produces intense shadows that are still full of colour.

cadmium yellow pale cadmium red pale alizarin crimson cobalt blue

French ultramarine viridian sap green

yellow ochre burnt sienna burnt umber Payne's grey

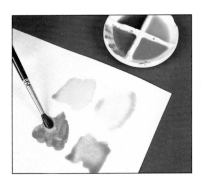

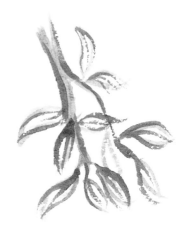

Make a page of brush marks to discover what your brushes are capable of. These marks were made with a round brush (top row) and a flat brush (bottom row).

Watercolour dries lighter than it appears when wet, so test each colour on spare paper before applying it to the actual picture.

extremely difficult to match the exact colour again.

When using tube colours, squeeze a small quantity of paint onto the palette. Then pick up a little of the paint on the brush, transfer this to the mixing dish and add water, a little at a time, until you have achieved the required strength of colour. With pan colours, moisten the paint with a brush to release the pigment, then transfer the colour to the palette (or use the wells set in the inside lid of the paintbox) and mix it with water to the strength required.

Try to keep your colours fresh and clean at all times. Rinse your brush each time you use a new colour, and replace the water in your jar frequently as dirty water contaminates the colours and mutes their brilliance.

BRUSH STROKES

In oil and acrylic painting the thick paint is normally applied with stiff bristle brushes in a series of choppy strokes. The watercolour technique is quite different, requiring fluid, gliding movements to form continuous strokes. Unless you are painting fine details, move your whole arm to create flowing strokes. Keeping your painting hand relaxed, hold the brush around the middle of the handle. If you paint from the wrist as though you were writing with a pen, the strokes will be stiff and cramped.

Try out different brush techniques using both round and flat brushes, like those illustrat-

STRETCHING WATERCOLOUR PAPER

1

Cut four strips of brown paper gum-backed tape to length.

2

Immerse the paper in cold water for a few seconds.

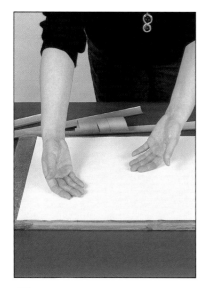

3

Lay the paper flat on the board. Smooth it out from the centre using the backs of your hands.

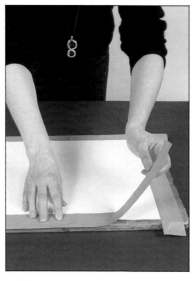

4

Stick down the edges of the paper with the strips of gummed tape and leave to dry.

ed here. The pressure exerted with the brush controls the width of the stroke. For fine strokes, the tip of the brush should glide across the paper. To make wider strokes, press down with the brush. You will find that the texture and absorbency of the paper will influence the marks you make.

STRETCHING PAPER

Most papers will cockle (buckle) when they become wet with watercolour paint. This can be avoided by stretching paper before starting to work on it. The paper is first soaked in water, allowing it to expand, and is then fastened down securely to a board so that it dries taut.

Have ready a drawing board, a sheet of watercolour paper trimmed to 2.5 cm (1 in) smaller than the board, a sponge, and four strips of brown paper gum-backed tape cut 5 cm (2 in) longer than each side of the paper.

Immerse the paper in cold water (the soaking time depends on the weight of the paper — lightweight papers require no more than a minute, heavier papers, perhaps a couple of minutes). Hold the paper by one corner, shake the surplus water off gently and lay it flat on the board. Moisten the gummed strips with a wet sponge and stick them along each edge of the paper so that two-thirds of their width is attached to the drawing board and one-third to the paper. Tape one side of the paper first, then

LAYING FLAT WASHES

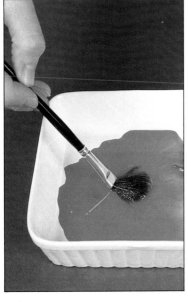

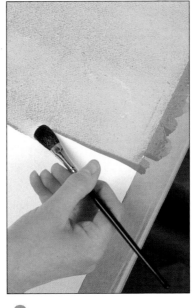

1
Mix up plenty of your chosen colour; the paint should be fluid but quite strong in hue.

2
Tilt the board slightly. Lay a band of colour across the top of the paper. Then continue down the paper with overlapping strokes, working in alternate directions and picking up the excess paint from the previous stroke each time.

3
Finally squeeze out the brush and soak up the excess colour at the base of the wash. Leave the wash to dry in the same tilted position.

the two adjacent sides, and finally the remaining side, opposite the first strip.

Allow the paper to dry flat, away from direct heat, for several hours. As the paper dries, it will shrink and become taut. Do not use until completely dry.

LAYING WASHES
There are three basic types of wash: the flat wash, the graduated wash and the variegated wash. All of these can be applied on either a dry or a damp surface, although the latter helps the wash to flow more evenly.

Washes must be applied quickly and in one go, so mix up plenty of paint - you always need more that you think. The colour should be fluid, but quite strong, to compensate for the fact that it will dry much lighter on the paper. Tilt the board slightly to allow the paint to flow downwards.

Flat Wash
A flat wash is so called because it is all the same tone. To lay a flat wash, first moisten the stretched paper. Load a brush with paint and take it across the paper in one stroke. A bead of paint will form along the bottom of the stroke.

Load the brush again and, working in the opposite direction, lay another stroke beneath the first, slightly overlapping it and picking up the excess paint from the bottom of the previous stroke. The excess paint will reform along the base of the second stroke. Continue working down the paper in alternate

directions until the whole area is covered. Then squeeze the excess paint out of the brush with your fingers and stroke the bottom band again lightly to pick up the excess colour.

Let the wash dry in the same tilted position, otherwise the paint will flow back and dry leaving an ugly tidemark.

Gradated Wash

A gradated wash starts with strong colour at the top, gradually lightening towards the bottom. The method of application is exactly the same as for a flat wash, except that with each successive stroke, the brush carries more water and less pigment. Gradated washes are very useful when painting skies, where the colour is most intense at the zenith and fades gradually towards the horizon.

It takes a little practice to achieve an even gradation, the secret is to keep the paint as fluid as possible so that each brush stroke flows into the next.

Moisten the area to be painted and tilt the board at a slight angle. Load a large brush with paint at full strength and lay a band of colour across the top of the paper, taking care not to lift the brush until you reach the end of the stroke. Quickly add more water to the paint in the palette and run the brush under the first line of paint picking up the paint which has run down to the base of the first band. Repeat this process. Each succeeding stroke will get weaker and the wash paler as it reaches the bottom of the paper.

Variegated Wash

Variegated washes are similar to gradated washes, except that several different colours are used instead of just one. This technique is very effective for skies and landscapes as demonstrated in the project which commences on page 61.

LAYING GRADATED WASHES

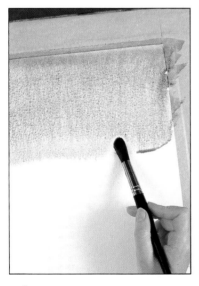

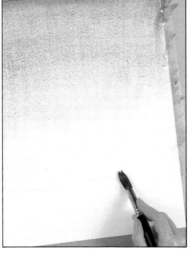

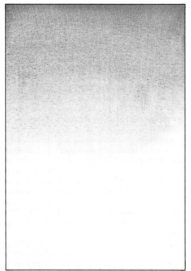

1
Lay a band of full-strength colour across the top of the paper. Lighten the colour with more water and lay another band under the first, picking up the paint at the bottom of the first band.

2
Continue in this way, applying increasingly diluted tones until you reach the bottom of the paper.

3
Leave the wash to dry in a tilted position.

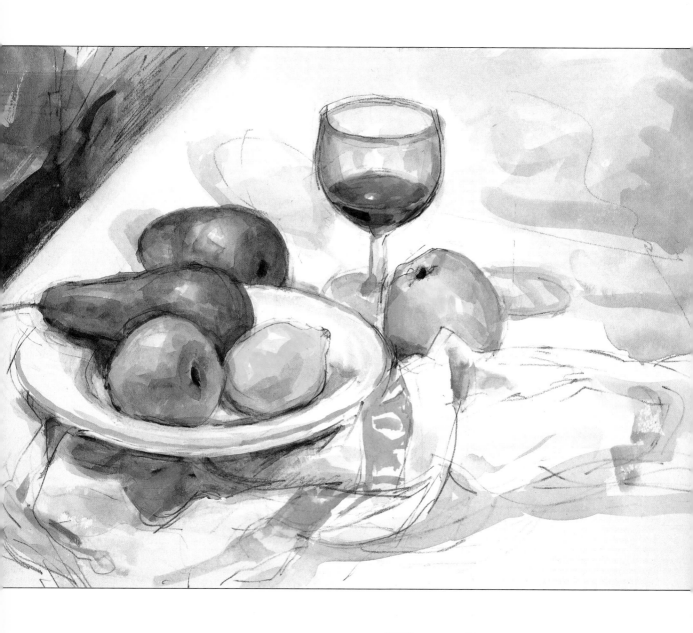

WORKING FROM LIGHT TO DARK

Working from light to dark is the classical method of building up a watercolour painting; the artist starts with the palest of washes and builds up the tones and colours very gradually to the density required. This structured method of using watercolour is sometimes called "wet-on-dry", and is especially useful for modelling the forms of objects to suggest volume.

In this informal still life the artist applies crisp strokes and washes of transparent colour, one on top of the other, to suggest the firm but rounded forms of the fruits.

~

Elizabeth Moore
Still Life
28 x 38cm (11 x 15in)

~

LIGHT TO DARK TECHNIQUE

Because watercolour is transparent, light colours cannot be painted over dark ones; the dark areas have to be built up gradually by overlaying colours in successive layers. Working on dry paper, the lightest tones are applied first and left to dry; then progressively darker tones are built up where required, leaving the lightest areas intact. This process results in richer, more resonant passages than can be achieved by painting with a single, flat wash of dense colour.

This technique requires a little patience, because it is essential to allow each layer of paint to dry before applying the next; if you do not, the colours will simply mix and the crispness and definition will be lost. To speed up the process, you can use a hairdryer on a cool-to-warm setting. Remember also that the characteristic freshness and delicacy of the medium is lost if too many washes are allowed to build up, so always test your colours on scrap paper before applying them to the painting; a few layers, applied with confidence, will be more successful than colours muddied by constant reworking.

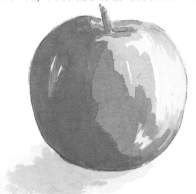

This simple image demonstrates how to build up overlapping washes of colour from light to dark and create a convincing sense of three-dimensional form.

STILL LIFE

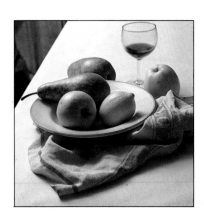

Left: A lamp was placed above and to the left of the still-life group; this powerful light source creates strong shadows that help to define the forms of the fruit.

1

Make a light pencil drawing of the group. Begin with the lightest tones, keeping all your colours pale and transparent. Note where the brightest highlights are and indicate them by leaving the paper white.

Using a medium-sized round brush, paint the wine with alizarin crimson. Paint the lemon and the apple on the right with lemon yellow; the apple on the plate with sap green, and the pears with varied tones of raw umber and sap green. Indicate the bowl of the wine glass and the cast shadows on the cloth with Payne's grey. Paint the pattern on the cloth with cadmium red.

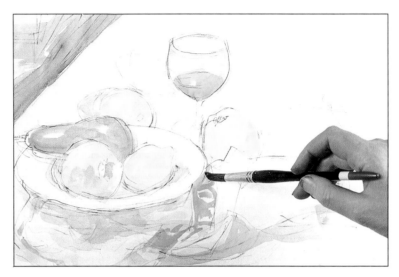

2

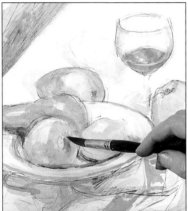

Prepare slightly stronger mixes of your colours and add the mid-tones, working around the highlights and paler tones. Add strokes of alizarin and cadmium red to the wine. For the pears, apply overlaid washes of raw umber and sap green, using curved strokes that convey the rounded forms of the fruits. Model the apples with strokes of sap green and lemon yellow, and strengthen the colour of the lemon with overlaid washes of lemon yellow. Paint the rim of the plate with sap green.

3

Continue developing the mid-tones and shadows, leaving the highlights intact. Add hints of pure colour here and there to add "zing". The subtle modulations of colour and tone are achieved by overlaying strokes of delicate, transparent pigment, like so many layers of tissue paper. Observe, too, how the brush strokes are left largely unblended to create textural interest.

Finally, darken and strengthen the tones in the wine glass, the fruits and the shadow beneath the plate.

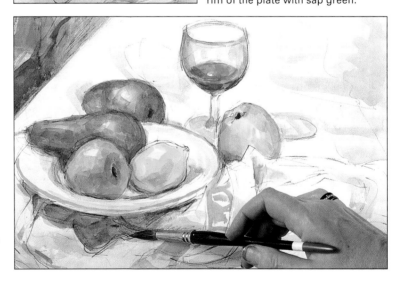

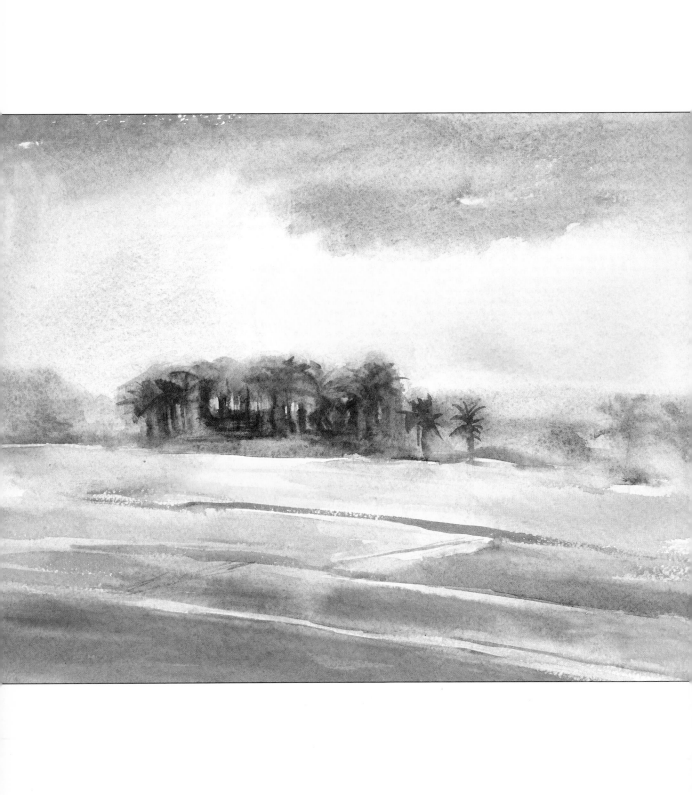

Technique
7

VARIEGATED WASHES

This attractive picture was painted on-the-spot in Goa, India. It relies for its effect on the way each colour blends softly into the next with no hard edges, evoking the steamy atmosphere of a tropical landscape after a monsoon rain-storm. Working on well-dampened paper, the artist applied strokes of variegated colour to the sky and landscape areas and allowed them to spread and diffuse to create the effect of the watery sky and the flooded fields. A heavy stretched paper with a Not (cold-pressed) surface, which would not buckle when heavy washes were applied, was used.

Penelope Anstice
Indian Landscape
28 x 38cm (11 x 15in)

USING VARIEGATED WASHES

In watercolour, exciting and unpredictable effects can be obtained with variegated washes - laying different coloured washes side by side so that they bleed gently into each other where they meet. Variegated washes need to be applied quickly and confidently, so it is advisable to mix the colours in advance.

Working with your board at a slight angle, paint a strip of colour onto well-dampened paper. Rinse the brush, then take a second colour and quickly lay it next to the first. Repeat this process with any subsequent colours. The colours will spread and diffuse on the damp paper and the edges will melt softly into each other. Resist the temptation to push the paint around too much once the wash has been laid as you risk spoiling the soft, delicate effect. Leave the wash to dry at the same tilted angle.

When working on damp paper you will need to mix your colours slightly stronger than you think is necessary. This is because the pigments spread and mix with the water on the paper surface, and will dry to a lighter shade than when first applied.

Variegated washes are often used in painting skies and landscapes, when soft transitions from one tone or colour to another are required.

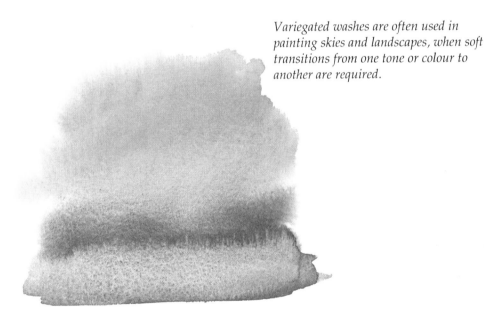

INDIAN LANDSCAPE ────────────

1

Lightly sketch in the main elements of the composition with a soft pencil.

Materials and Equipment

• SHEET OF 410GSM (200LB) NOT (COLD-PRESSED) SURFACE WATERCOLOUR PAPER, STRETCHED • SOFT PENCIL • KNEADED PUTTY ERASER • LARGE BRUSH OR SOFT SPONGE • WATERCOLOUR BRUSHES: MEDIUM-SIZED AND SMALL ROUNDS • WATERCOLOUR PAINTS: MAGENTA, NAPLES YELLOW, CADMIUM YELLOW PALE, FRENCH ULTRAMARINE, YELLOW OCHRE, CERULEAN, EMERALD GREEN, INDIAN RED, VIRIDIAN

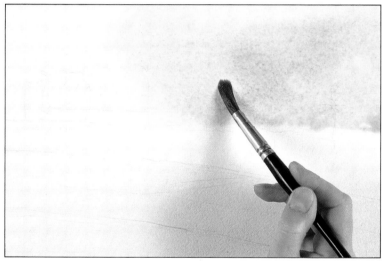

2

Wet the entire picture surface with clean water using a large brush or soft sponge. On the right of the picture, just above the horizon, drop in a mixture of magenta and a hint of Naples yellow. Either side of it, add a mix of Naples yellow and a touch of cadmium yellow pale. Allow the colours to bleed into each other where they meet.

3

Complete the sky area by sweeping in a pale wash of ultramarine mixed with a touch of yellow ochre to temper the blue. Work quickly and loosely, varying the tones of blue so that the sky is not too flat. Mix a darker blue from cerulean and a hint of yellow ochre and apply this along the horizon to provide a background wash for the misty trees. This wash will blend into the sky colour leaving a soft edge.

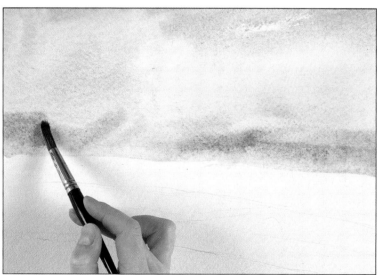

4

Then indicate the marshy fields. Using a medium-sized round brush, sweep a few broad strokes of clean water across the lower half of the picture, leaving tiny slivers of dry paper between the strokes. Mix the following paints on the palette: yellow ochre and Naples yellow; emerald green and cadmium yellow pale; and ultramarine, magenta and Naples yellow. Sweep these three mixes into the wet brush strokes, allowing them to blend and fuse slightly where they meet. Leave to dry completely.

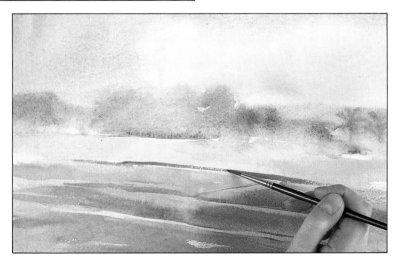

5

Paint the palm trees on the right with a pale tint of magenta and ultramarine. Re-wet the area of the main clump of trees and drop into it a mixture of magenta, ultramarine and yellow ochre. Allow the colours to blend partially.

6

Strengthen the colours in the fields using greys mixed from magenta, ultramarine and Naples yellow, and an earth colour mixed from Indian red and yellow ochre in the immediate foreground. Mix a purplish brown from cerulean, Indian red and yellow ochre and use a small round brush to add a few drybrushed lines (see pages 67-73) to add texture. Observe how the slivers of white paper between the strokes look like pools of water lying on the surface of the fields.

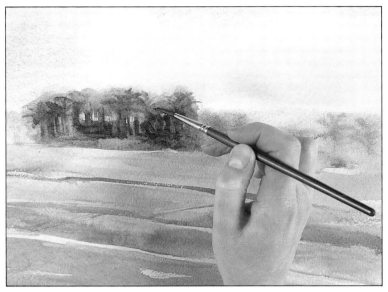

7

Re-wet the main clump of trees and work into it using a small round brush and cerulean, Indian red and yellow ochre. Paint the darker trunks and foliage of the trees with mixtures of viridian, ultramarine and cerulean, but don't overstate them - keep the forms soft and amorphous, otherwise you will lose the impression of mistiness.

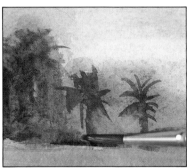

Left: This detail shows how the forms of the trees are softened by lifting out some of the colour using a wet brush.

8

Finally, use a medium-sized round brush and a pale grey mixed from ultramarine and yellow ochre to paint the dark rain cloud near the top of the picture. Leave the painting to dry flat.

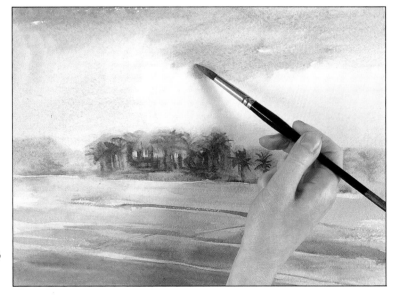

DRYBRUSH PAINTING

Quick, and decisive brush strokes are a key element in watercolour painting. The more that watercolour is manipulated, the more likely it is that the sparkle and spontaneity will be lost. This is where the drybrush technique is invaluable, because it can suggest meticulous detail and texture without the painting appearing overworked.

Drybrush is a highly expressive and versatile technique, particularly in landscape painting. It can be used to suggest anything from broken cloud to the sparkle of sunlight on water, the rough texture of rocks and tree bark, and the movement of trees and grass blowing in the wind.

In this painting there is an interesting contrast between the smooth, delicate washes of colour used to suggest the soft plumage of the white duck, and the loose, drybrushed texture of the grass.

~

Penelope Anstice
White Duck
36 x 56cm (14 x 22in)

~

DRYBRUSH TECHNIQUE

Drybrushing in watercolour produces soft-edged lines of fascinating irregularity in contrast to the smooth washes often associated with the medium. To produce a drybrush stroke, moisten the brush with very little water and pick up a small amount of paint on the tips of the bristles. Flick the brush lightly across a rag or paper tissue to remove any excess moisture, then skim the brush lightly and quickly over a dry painting surface.

This technique works best on a rough or medium-rough paper. The surface of a good-quality rough paper has a definite "tooth" and when a colour wash is laid sparingly over the top, some of the pigment gets trapped in the hollows and some adheres to the peaks. This leaves tiny dots of white which cause the wash to sparkle with light. Drybrush strokes have a ragged quality that is ideal for suggesting natural textures such as weathered rocks and wood, tree bark, grass and clusters of foliage.

The drybrush technique allows you to give an impression of detail and texture with minimal brushwork, thus avoiding the pitfalls of a clumsy, overworked painting. When painting water, for example, a deft stroke of dry colour that leaves tiny dots of white paper showing through can suggest the sparkle of sunlight on the surface. This quality is particularly useful in watercolour painting, which relies on freshness and simplicity of execution for its effect.

Drybrushing one colour or tone over another produces lyrical passages of colour with an almost three-dimensional quality. The tiny specks of untouched white paper sparkle through and enhance the translucent effect.

WHITE DUCK

Left: Ducks and geese are a favourite subject for this artist. This painting was done largely from memory, with the aid of a photograph.

Materials and Equipment

• SHEET OF 300GSM (140LB) ROUGH SURFACE WATERCOLOUR PAPER, STRETCHED • SOFT PENCIL • KNEADED PUTTY ERASER • WATERCOLOUR BRUSHES: LARGE AND SMALL ROUNDS, 13MM (½IN) FLAT • WATERCOLOUR PAINTS: EMERALD GREEN, CERULEAN, CADMIUM YELLOW PALE, FRENCH ULTRAMARINE, BURNT UMBER, VERMILION, YELLOW OCHRE, NAPLES YELLOW AND CHINESE WHITE • TISSUES

1

With a soft pencil lightly sketch the shape of the duck and indicate the trees in the background.

2

Mix emerald green with a little cerulean and cadmium yellow pale and mix with lots of water to make a pale tint. Working on dry paper, and with a fairly dry, large round brush, lightly scrub the colour over the area around the duck. These drybrushed strokes of cool colour will shine up through the subsequent paint layers, creating a lively colour effect.

3

When the first colour is completely dry, mix cadmium yellow pale and a touch of cerulean to make a warmer, lighter green, again diluted to a pale tint. Scrub the colour on as before, overlaying the cooler green beneath.

4

Mix emerald green and a touch of French ultramarine and indicate a few daisies in the foreground grass using a small, well-pointed round brush.

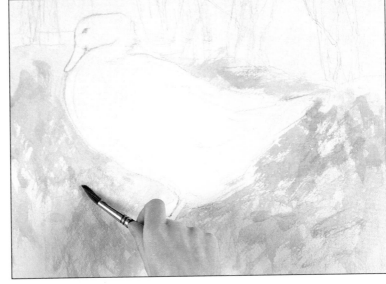

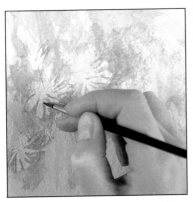

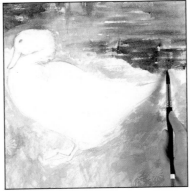

5

Using a large round brush, apply a few strokes of clean water to the stream in the background. Brush in a pale mixture of burnt umber, ultramarine and a touch of vermilion. Apply the colour with rapid horizontal strokes, allowing some strokes to spread on the wet paper. Lightly skim the surface of the paper so as to leave little flecks of white paper here and there that indicate the sparkle of the water. Leave to dry.

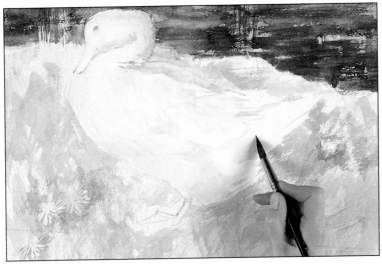

6

Darken the wash with more burnt umber and ultramarine and add further horizontal strokes to the stream, working carefully around the duck's head.

Mix a pale wash of ultramarine with a touch of cerulean and begin painting the cool shadows on the duck's head and body.

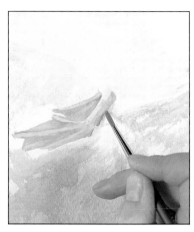

7

Paint the duck's feet with a pale wash of cadmium yellow pale and vermilion, darkening the back foot with a touch of ultramarine to push it back in space. Allow to dry, then add a second wash of colour except on the bones of the feet.

8

For the duck's beak use Naples yellow and a hint of vermilion, lifting out some of the colour with a tissue to create the highlight. Paint the shadow under the beak with the same mix, darkened slightly with ultramarine. With a small round brush wet the eye area with water and then add a drop of burnt umber and ultramarine in the centre and work the colour out towards the edges. This prevents the eye from appearing too hard and unnatural. Do the same with the breathing hole in the beak. Using the flat brush, model the form of the head with pale shadows mixed from ultramarine and yellow ochre.

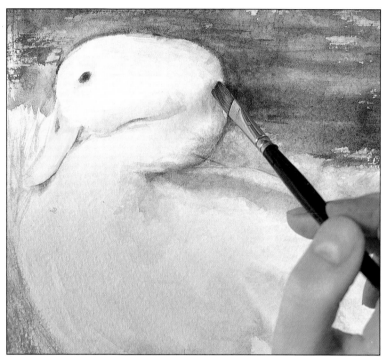

9

Introduce some colour variation in the grass with further drybrush strokes using varied mixtures of ultramarine and cadmium yellow pale, with hints of very pale vermilion here and there. Use the tip of the brush to paint some tall, spiky grasses in the foreground with a darker shade of green.

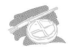
10

Continue painting the subtle shadows and highlights on the plumage with the large round brush. For the cool shadows on the back and wing use ultramarine and yellow ochre diluted to a pale tint; use the same colour, but stronger, for the dark shadow under the tail. The duck's breast reflects light from the sun, so paint this area with Naples yellow varied with yellow ochre. Leave to dry.

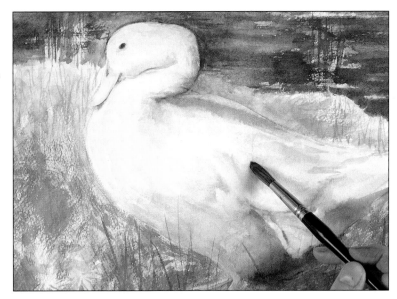

11

Mix a dark wash of ultramarine and cadmium yellow pale, warmed with a little vermilion, and paint the shadow cast by the duck on the grass. Apply the pigment loosely and quite dry, not as a solid block of colour.

12

With a wash of cadmium yellow pale and a touch of emerald green, add some warm hints of sunlight to the grass, again with a dry flat brush.

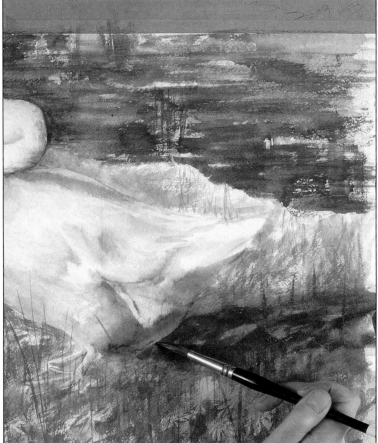

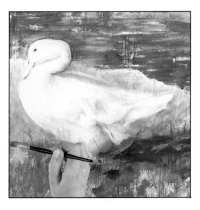

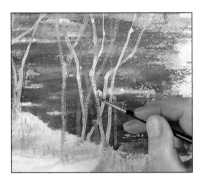

13

Paint the saplings at the edge of the water with Chinese white overlaid with a pale brown mixed from yellow ochre and Naples yellow. The paint should be quite thick, and applied very lightly with a dry small round brush so that it catches on the "tooth" of the paper and creates broken strokes that simulate the pattern of the bark.

14

With the same brush, paint the white daisies with Chinese white, and the yellow ones with a mix of cadmium yellow pale and white.

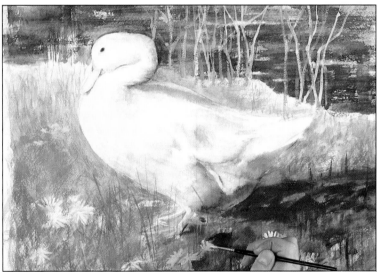

15

Paint the centres of the white daisies with cadmium yellow pale. Mix a dark green from ultramarine and Naples yellow and, with a dry flat brush, paint some tall grasses in the foreground. Use the same colour and a small round brush to paint the centres of the yellow daisies. Finally, lightly stroke in a few lighter grasses with a mix of Naples yellow and chinese white.

Below: This detail from the bottom left of the painting demonstrates the beauty and expressiveness of different-coloured drybrush strokes applied one on top of the other.

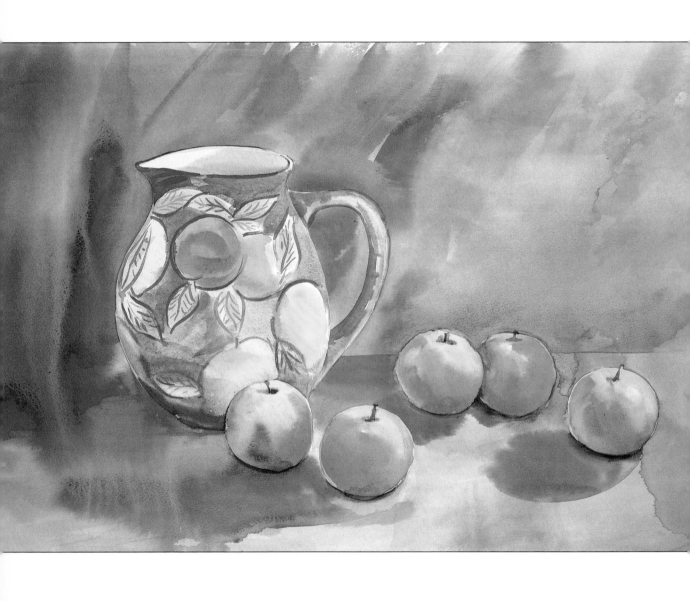

Technique
9

WET-INTO-WET

This still-life painting is a wonderful example of the interaction of water, paint and paper that is unique to the watercolour medium. The artist worked rapidly and intuitively, flooding the background colours onto wet paper and controlling the direction of the flow by tilting the board in different directions. The apples were painted while the background was still wet so as to create a slightly suffused effect. The result is more of a lyrical impression of the subject than a literal interpretation.

~

Penelope Anstice
Apples and Jug
38 x 56cm (15 x 22in)

~

WET-INTO-WET TECHNIQUE

Watercolour's reputation as a spontaneous, unpredictable medium is based largely on the effects produced by working wet-into-wet. In this technique, colours are applied over or into each other while they are still wet, so that they blend together softly with no hard edges. It is one of the most satisfying methods to work with, producing lively colour mixtures.

This technique is ideal for painting large expanses of soft colour, for example in skies and misty landscapes. When painting delicate or hazy subjects - flowers, fruits, shapes in the far distance - wet-into-wet allows the colours to blend naturally on the paper without leaving a hard edge.

For this technique it is best to use a heavy-grade paper (410gsm/200lb or over) which will bear up to frequent applications of water without warping. Lighter papers will need to be stretched and taped to the board (see pages 53-54). Moisten the paper with clean water using a large brush or soft sponge. Blot off any excess water with a tissue so that the paper is evenly damp, with no pools of water lying on the surface. This technique is not for the faint-hearted; you must work quickly and confidently, charging the colours onto the paper and allowing them to spread and diffuse of their own accord. Wet-into-wet is only partially controllable - that is part of the excitement - but you can tilt the board to direct the flow of the colours and create interesting patterns of diffusion. Keep a tissue handy for mopping up any colour where you don't want it.

A common mistake when working wet-into-wet is to dilute the paint too much, with the result that the finished painting is weak and insipid. Because the paper is already wet you can use quite rich paint - it will soften on the paper but retain its richness. You must also compensate for the fact that the colour will dry much lighter than it appears when wet.

Wet-into-wet washes create soft, diffused shapes which perfectly capture the amorphous nature of cloud formations, mist and rain.

APPLES AND JUG

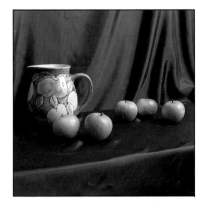

Left: This group was kept very simple so as to give the artist the freedom to apply broad washes of colour without having to work around awkward shapes. This simplicity is underlined by the restricted colour scheme of blues, reds and yellows.

Materials and Equipment

• SHEET OF 640GSM (300LB) NOT (COLD-PRESSED) SURFACE WATERCOLOUR PAPER, STRETCHED • SOFT PENCIL • KNEADED PUTTY ERASER • WATERCOLOUR BRUSHES: 25MM (1IN) FLAT, LARGE AND SMALL ROUNDS • WATERCOLOUR PAINTS: PRUSSIAN BLUE, MAGENTA, CADMIUM YELLOW PALE, NAPLES YELLOW, ALIZARIN CRIMSON, WINSOR GREEN, FRENCH ULTRAMARINE, VERMILION, YELLOW OCHRE, PAYNE'S GREY AND BURNT UMBER • TISSUES

1

Make a light outline sketch of the jug and apples and indicate the pattern on the jug.

2

Using a large flat brush, wet the paper with clean water, working around the shapes of the jug and apples. Prepare a diluted wash of Prussian blue mixed with a little magenta and apply this all over the wet area; apply the paint loosely, varying the direction of the brush strokes to create a lively effect.

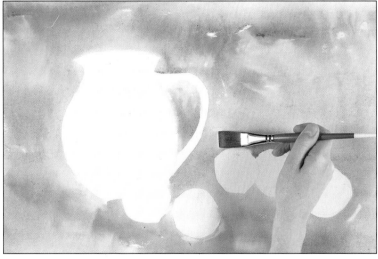

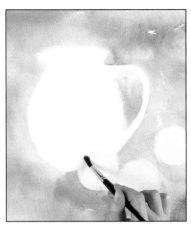

3

While the background is still damp, use a large round brush to paint the apples with a pale wash of cadmium yellow pale and a little Naples yellow.

4

Paint the pattern on the jug, again with pale washes; first fill in each shape with water, then drop in the colours - alizarin crimson for the plums, cadmium yellow pale for the lemon, and adding Winsor green to the latter for the leaves. Allow the colours to spread and soften on the paper.

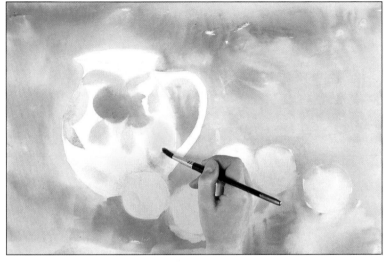

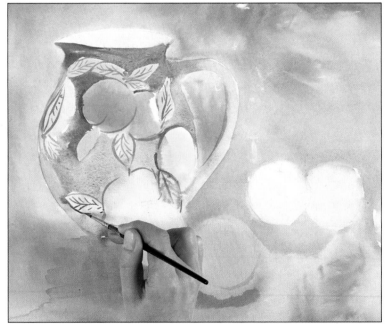

5

Fill in the background colour of the jug with diluted French ultramarine. With a small, well-pointed round brush, paint the outlines of the leaves and fruit with a darker mix of ultramarine.

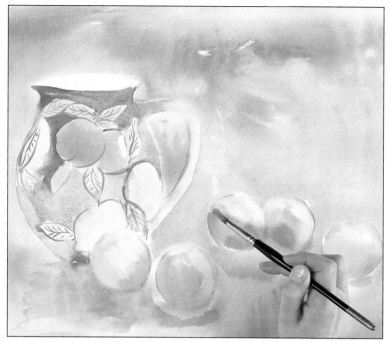

6

Exploit the wet-into-wet method to depict the apples (except for the one on the extreme right) with a variety of reds and greens. For the reds, use various mixtures of alizarin crimson, vermilion and yellow ochre; for the greens, a pale wash of cadmium yellow pale with a touch of Prussian blue. Moisten each apple with clean water, then apply the colours and allow them to fuse slightly. This gradual merging of the two colours creates a natural-looking, rounded contour.

7

Make sure the background wash is completely dry. Mix a large wash of Prussian blue and magenta, this time slightly stronger than the first wash. Re-wet the background with clear water, then apply the paint with broad, loose strokes, leaving patches of the undertone showing through in places. Use a smaller brush to apply colour in the gaps between the apples.

Tilt the board in various directions to encourage the paint to move around and do interesting things; for example, where wet paint flows back into damp paint, it will dry with a hard edge which adds texture and interest to the large expanse of background area. Leave to dry.

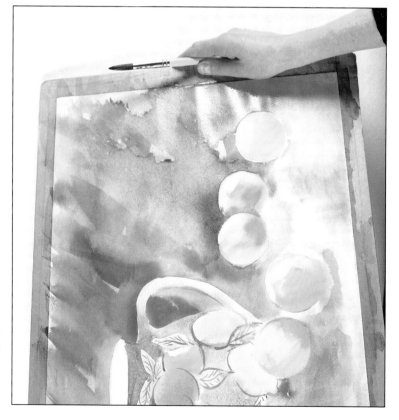

8

Wet the left half of the background and apply a third wash of Prussian blue and magenta, this time much darker than before. Use the same colour to paint the shadows on the table; first wet the shadow shapes, then fill them with paint and allow the paint to bleed softly into the surrounding areas, but use the brush to guide the paint away from the edges of the apples to keep them crisply defined. To anchor the apples to the table, darken the shadows directly beneath them with a touch of Payne's grey.

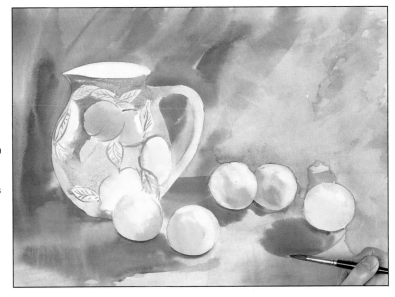

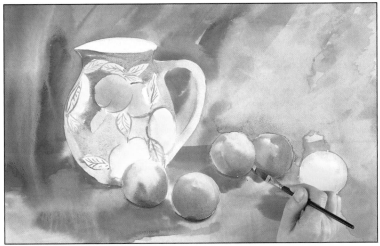

9

Mix yellow ochre and Prussian blue and apply this to the darkest areas of the apples while they are still wet, allowing the colour to merge into the red and green.

10

Paint the deeper shade on the russety apple on the right with the same colour used in step 9, then apply a stroke of alizarin crimson near the left edge and allow the colours to merge.

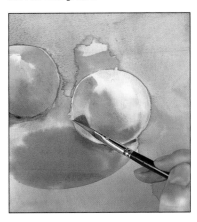

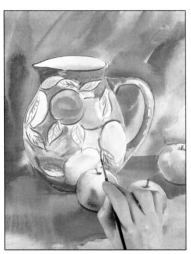

11

Paint the apple stalks with burnt umber and Payne's grey. Paint the darker tones on the jug and its handle with a deeper shade of ultramarine. Wet the shadow shape inside the jug and apply a wash of Naples yellow, darkened with a touch of ultramarine at the base of the shadow. Deepen the colours on the jug's pattern with further washes of the same colours used in step 4. Leave to dry, then use a strong tone of ultramarine and a small round brush to define the rim of the jug and sharpen the linear details on the jug's pattern.

12

Finally, re-wet the right-hand side of the background and, using a large flat brush, apply a loose wash of diluted alizarin crimson and magenta.

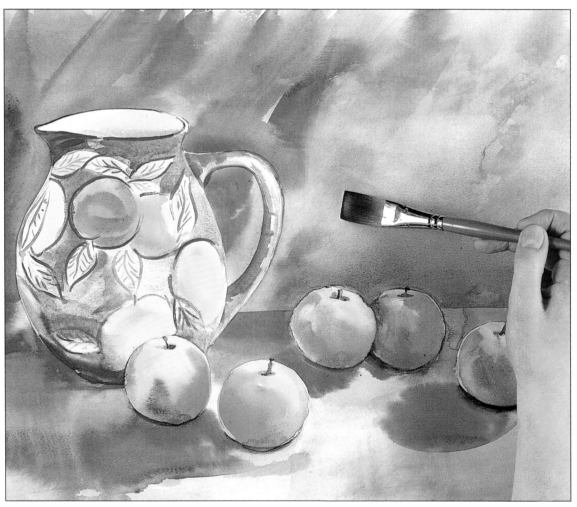

ACRYLICS
BASIC TECHNIQUES

PRIMING WITH ACRYLIC (POLYMER) GESSO

Acrylic paints can be used on either primed or unprimed surfaces, depending on the effects you seek to achieve. An absorbent surface which is unprimed, such as raw canvas, cloth or plastered walls, will absorb the pigment and dry to an even, matt (flat) finish which some artists find desirable. However it is usual to prepare surfaces that are absorbent or dark in colour, such as hardboard (masonite), with acrylic gesso primer which is inexpensive to buy readymade. Brushed onto the support prior to painting, it dries quickly to provide a matt, even surface to which the paint adheres readily. Very smooth surfaces such as hardboard should be lightly sandpapered before applying the gesso. Using a household paintbrush, apply two or three thin coats, each one at right-angles to the one before. Allow each coat to dry before the next is applied. For a smooth painting surface, dilute the primer to a milky consistency with water.

If you prefer a more textured painting surface, use it straight from the jar (or with just a little water) and apply it with rough brush strokes. Paper does not require priming.

MIXING PAINT AND MEDIUM

As mentioned earlier, there are various mediums which can be added to the paint to produce particular effects. Acrylic mediums appear milky white when squeezed out of the tube, but dry transparent. Simply squeeze a small pool of medium onto your palette along with your colours. Mix the required colours together then scoop up some medium and work it into the paint.

BRUSH STROKES

One of the great pleasures of acrylic painting is the way the paint responds to the brush. Each type of brush leaves a dif-

PRIMING SUPPORTS

1 Apply a smooth coat of primer, working the brush in one direction only. Allow to dry.

2 Apply a second coat of primer so that the strokes run at right-angles to those laid down in the first coat.

ferent kind of mark in the paint and performs a different task.

Paint can be applied rapidly and spontaneously or slowly and methodically; in thick, short strokes and dabs or thin, transparent washes; it can be skimmed over the surface of the canvas to create lively, broken strokes in a technique known as drybrushing, or laid on with a circular motion to produce a thin veil of colour called a scumble.

PRECAUTIONS

The speed at which acrylics dry is one of their major attractions, but the drawback is that they dry equally quickly on palettes and brushes - and once dry they are impervious to water.

To prevent paint drying on your brushes during a painting session, keep them in a jar of clean water whenever you are using them. It is even better to

Use a palette knife or painting knife to mix pigment and medium together on the palette.

lay them flat in a shallow tray of water - that way the bristles will not get distorted.

Always be sure to moisten your brushes with water before loading them with acrylic paint; otherwise the paint will stick to the dry bristles and gradually build up a stiff film that ruins them. If brushes do become caked with paint, soak them

overnight in methylated spirit. This should loosen the paint sufficiently for it to be worked out under running water. Then wash the brushes in mild soap and warm water.

To prevent paints from drying out on the palette, spray them periodically with a mist of water. Special "staywet" palettes are available which keep paints moist for days. Use plastic palettes for ease of cleaning, and wash them immediately after use. If paint becomes caked on the palette, leave it to soak in warm water for an hour and then peel or scrape it off.

Once dry, acrylic paint is almost impossible to remove from any absorbent surface, so take the precaution of wearing old clothes and shoes when working, and protect the surrounding surfaces with sheets of newspaper.

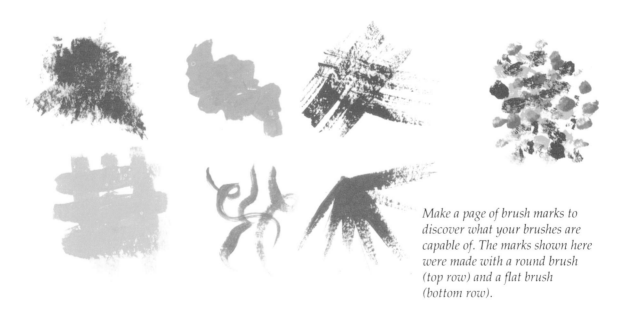

Make a page of brush marks to discover what your brushes are capable of. The marks shown here were made with a round brush (top row) and a flat brush (bottom row).

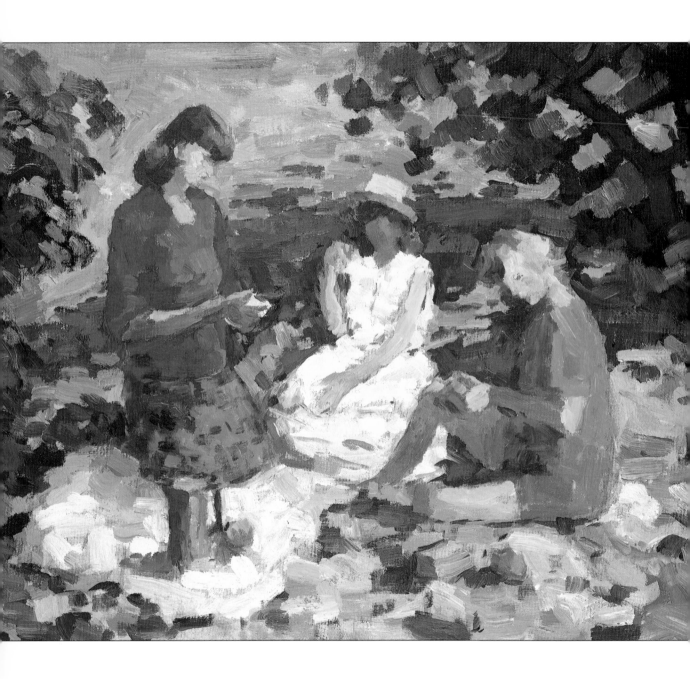

USING BROKEN COLOUR

In this painting the artist has adopted the Impressionist technique, using broken brush strokes of thickly applied paint in vibrant hues to create a shimmering web of colour. The paint, which is rich and buttery in consistency, has been applied in separate touches or strokes of a well-loaded bristle brush, building up wet layers over dry with some mixing of colour wet-into-wet on the surface of the painting. The lively dragged, broken and slurred brushwork gives a vital sense of light flickering off and blurring forms, evoking the atmosphere and light of summer.

~

Ted Gould
The Picnic
41 x 51 cm (16 x 20in)

~

85

BROKEN COLOUR TECHNIQUE

The term "broken colour" refers to a method of applying small strokes and dabs of different colours next to and over each other, so breaking up the paint surface into hundreds of tiny patches of colour, rather like a mosaic. When seen from the normal viewing distance these strokes appear to merge into one mass of colour, but the effect is different from that created by a solid area of smoothly blended colour. What happens is that the incomplete fusion of the strokes produces a flickering optical effect on the eye and the colours appear more luminous than a flat area of colour.

This technique is usually associated with the French Impressionist painters, who were the first to exploit its full potential. The Impressionists were fascinated by the fleeting, evanescent effects of outdoor light and found that using small, separate strokes of colour was an ideal way to capture the shimmering quality of the bright sunlight of southern France.

Acrylic paints are well suited to the broken colour technique because they dry rapidly, allowing you to superimpose layers of paint without muddying those beneath. Used straight from the tube, acrylics have a stiff, buttery consistency which is ideal for building up thick layers of impasto in which the mark of the bristle brush remains apparent in the raised paint. In general, short-haired flat bristle brushes (known as "brights") give the best results, as they hold a lot of paint and also offer a degree of control over the marks made.

When applying thick strokes of colour in this way, beware of overworking the texture, which would make the painting become clogged and heavy-looking. Apply each stroke decisively to the canvas and leave it alone. It is also a good idea to follow the Impressionists' example and allow the colour of the tinted canvas to show through in places. In the demonstration painting, for example, the artist began by tinting the canvas with a warm, golden colour; unpainted patches of this ground colour were left visible among the thick patches of paint, which not only add warmth but also breathe air into the painting.

Drybrush is another method of creating broken colour effects. A just-damp brush is lightly charged with colour, then skimmed across the dry canvas or paper. The brush leaves a small deposit of colour on the raised grain of the support, letting tiny specks of white sparkle through. The broken, ragged quality of drybrush strokes is very expressive.

THE PICNIC

Above: This project painting was based on direct observation of the scene. The artist first made a tonal sketch in ballpoint pen to map out the major lights and darks, then a quick oil sketch to work out the main colour areas before embarking on the painting itself.

1

Start by staining the canvas with a warm tint mixed from cadmium yellow medium, sap green and a touch of ultramarine blue, diluted with water to a wash-like consistency. Apply the colour with a large flat brush, then rub it into the weave of the canvas with a cotton rag. Leave to dry. With a small filbert brush, broadly block in the main tones and outlines of the scene with a thin mixture of cadmium yellow medium, prism violet and ultramarine. Leave to dry.

2

Block in the lightest tones around the figures with thicker paint. (From this point on, add some retarding medium to your colour mixes to prolong the drying time of the paint and keep it workable.) Mix sap green, cadmium yellow medium and ultramarine blue in various proportions to create a range of warm, yellowish greens and cooler, bluish greens. With a medium-sized flat brush, apply short blocks of colour, varying the direction of the strokes to enliven the surface.

3

Block in the shadows in the grass and foliage using a medium-sized filbert brush and the same mixture, darkened with more ultramarine blue. Apply the paint thickly, using the body of the brush, and allow the brush marks to remain.

4

Rinse the brush and paint the whites of the picnic cloth and the central figure's dress. Use titanium white, modified with cool blues and violets in the shadows and spots of pink and yellow in the highlights. Again apply the colour using the flat of the brush, varying the direction of the strokes to follow the forms. Allow the colour of the stained canvas to break through the strokes and contribute to the feeling of sunlight.

Start blocking in the red areas with cadmium red medium, modified with hints of cadmium yellow medium and titanium white.

5

Continue working around the figure group, gradually building up a mosaic of thick, luscious colour. It is a good idea to work with two brushes, one carrying warm colours and one carrying cool colours, to avoid having to rinse out your brush too frequently. Paint the blue top of the left-hand figure and the blue vacuum flask with loose mixtures of ultramarine blue and titanium white, darkened with violet in the shadows.

6

Paint the flesh tones of the figures with a small filbert brush and varying proportions of cadmium yellow medium, cadmium red medium and titanium white, adding hints of prism violet and sap green in the cool shadowy tones, such as the right-hand figure's face and her raised leg. Enrich the shadows on the red dress with hints of violet.

7

Use the medium-sized filbert brush and the same flesh tone mixture, lightened with more titanium white, to suggest patches of bare earth in the grass and break up the greens. Paint the hair of the right-hand figure with the same colour. For the dark hair of the remaining figures use rich browns mixed from cadmium red medium, cadmium yellow medium, prism violet and ultramarine blue. Suggest the pattern on the left-hand figure's skirt with strokes of violet and sap green.

8

Continue working all over the canvas, modifying colours and tones as necessary and adding small touches of pure colour here and there to add luminosity to the picture. Suggest the features very sketchily – otherwise they will look too dominant.

IMPASTO

Impasto – thick, heavily textured paint – is most commonly associated with the direct, or "alla prima", style of painting, in which a picture is completed in one session, without a preliminary underpainting. Thick paint and rapid brush strokes allow the picture to be built up quickly and in a spontaneous manner, and this approach was adopted by the artist in this painting of a jug full of tulips. Thick layers of undiluted paint were applied directly onto the canvas, "sculpting" the pigment with a bristle brush to heighten its textural quality. The result is a highly tactile painting which emphasizes the strong forms of the flowers and foliage.

Kay Gallwey
Tulips
61 x 51cm (24 x 20in)

IMPASTO TECHNIQUE

Thick paint, heavily applied to the canvas so that it has a rough, uneven texture, is called impasto. In contrast to glazing – the methodical building up of thin layers of paint – impasto involves using the paint thickly, liberally and in a bold, direct manner. It is not a technique for the faint-hearted, but most artists enjoy the expressive and textural qualities that impasto can lend to a painting. Van Gogh's vibrant paintings, with their thick, swirling brush strokes are a classic example of this approach.

Impasto can be applied with a brush, a painting knife or a combination of the two. Use the paint straight from the tube, or diluted with just a drop of water so that it is malleable, yet thick enough to retain the marks and ridges left by the brush or knife. If you wish, the paint can be further stiffened by mixing it with gel medium, which will help the paint to retain the marks of the brush.

Flat bristle brushes are best for impasto work because they hold a lot of paint. Load the brush with plenty of colour and dab it onto the canvas, working the brush in all directions to create a very obvious, almost sculptural effect. The adhesive and quick-drying properties of acrylics mean that they can be used very thickly and yet will dry in a few hours, without fear of cracking.

An impasto painting should look free and spontaneous, but it actually needs careful planning. Just as colour loses its vitality when it is too thoroughly mixed on the palette, directly applied paint quickly loses its freshness when the pigment is pushed around on the canvas for too long. In any case, acrylic paint does not lend itself to being moved around once it is on the canvas because it dries so quickly. When using acrylics thickly you must decide in advance the position, direction and thickness of each stroke. Be sure your brush carries a liberal amount of paint, apply it with a clear sense of purpose, and then leave it alone.

To create a textured impasto, load a bristle brush with paint and make short, heavy strokes worked in all directions to create a very obvious, almost sculptural effect.

TULIPS

Right: These parrot tulips were chosen for their warm strong colours and textural petals and leaves. A simple setting and plain blue jug enhance the exuberant beauty of the flowers.

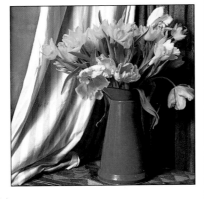

Materials and Equipment

• SHEET OF MEDIUM-TEXTURED CANVAS OR CANVAS BOARD • ACRYLIC COLOURS: BRILLIANT BLUE, COBALT BLUE, TITANIUM WHITE, RAW UMBER, QUINACRIDONE VIOLET, AZO MEDIUM YELLOW, CADMIUM YELLOW DEEP, CADMIUM SCARLET, NAPHTHOL CRIMSON, CADMIUM ORANGE, HOOKER'S GREEN, LIGHT GREEN OXIDE, CITRUS GREEN AND MARS BLACK • BRISTLE BRUSHES: MEDIUM-SIZED AND LARGE FLATS

1

Sketch out the composition with thin diluted paint, using blues, yellows and browns to establish the basic colour scheme. "Draw" the lines with a medium-sized flat bristle brush. The underdrawing is only a rough guide – any necessary adjustments can be done later.

2

Still using thin paint, start to establish the major tones and colours. With a large flat bristle brush, rough in the tones of the blue jug with broad strokes of brilliant blue and cobalt blue. Suggest the folds in the blue backcloth with titanium white and a touch of brilliant blue. Use raw umber and quinacridone violet for the dark backcloth and the patterned kilim on which the jug rests. Paint the yellow tulips with azo medium yellow, and the lightest parts of the orange-red tulips with azo medium yellow and cadmium yellow deep.

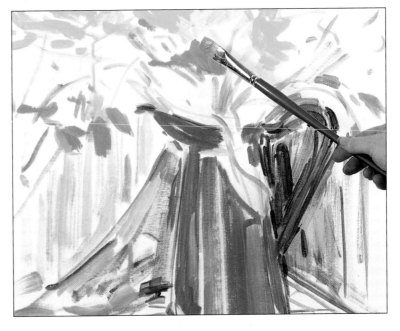

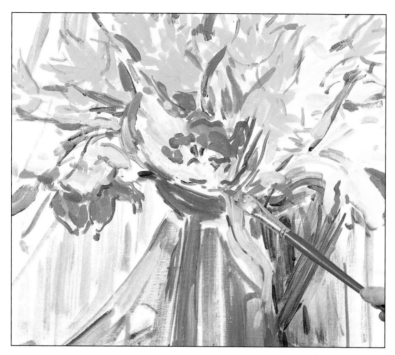

3

Using thicker paint, diluted with just a little water, paint the deepest tones on the orange-red tulips with various reds – cadmium scarlet, naphthol crimson and quinacridone violet. Paint the leaves of the tulips with thick, sinuous strokes using Hooker's green for the darkest tones, light green oxide for the medium tones and citrus green for the lightest tones, mixing all of these colours with titanium white.

4

Strengthen the tones on the blue jug and backcloth with thick paint, using brilliant blue and titanium white for the lights and cobalt blue for the darks. Paint the diamond pattern on the kilim using quinacridone violet, naphthol crimson, cadmium orange, mars black and brilliant blue mixed with white.

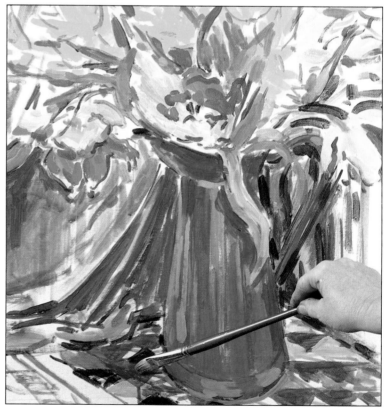

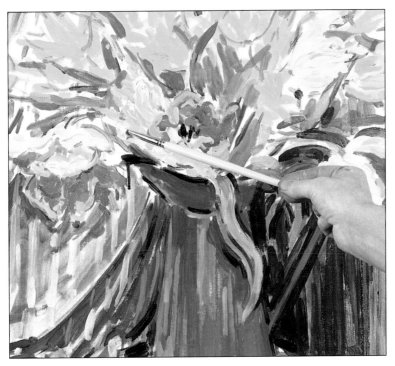

5

Paint the white stripes on the blue backcloth, adding a hint of brilliant blue to the white where the folds create shadows. Block in the dark cloth on the right with loose mixtures of raw umber, cadmium yellow deep and Hooker's green, scrubbing the paint on with vertical strokes of a fairly dry brush. Switch back to the medium-sized brush and paint the pale, creamy-coloured tulips with mixtures of azo medium yellow, titanium white and hints of cadmium scarlet. Use the paint thickly, undiluted, and apply it with prominent, textured brush strokes.

Right: This detail shows how the thick, juicy paint and swirling brush marks define the forms of the flowers and also lend rhythm and movement to the picture. The contrast of thick paint in the foreground, which appears to advance, and thinner paint in the background, which appears to recede, helps to create a sense of depth and three-dimensional space.

6

Finally, define the shadows on the tulip leaves with strokes of Hooker's green; this also emphasizes the graceful curves of the leaves. Refine the tones in the jug with further strokes of cobalt blue, brilliant blue and titanium white, blending the tones together with feathery strokes of the brush to model the jug's rounded form.

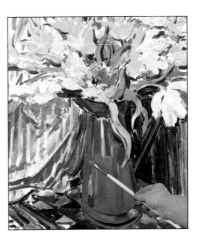

OIL PAINTING
BASIC TECHNIQUES

PRIMING THE SUPPORT

Canvas, board and other supports for oil painting must be sealed before being used, otherwise oils from the paint layer seep down into the canvas, leaving the paint impoverished and eventually prone to flaking or cracking. The traditional method is to apply a "ground" consisting of a layer of glue size and one or more layers of emulsion or gesso primer. The modern alternative is acrylic primer, which can be applied directly to the support without the need for glue size and is ready to paint on in about 30 minutes.

An economical primer that can be used on board (but not on stretched canvas) is ordinary matt white household paint, which provides a sympathetic semi-absorbent ground. However, use only good-quality paint, because cheap emulsions will quickly yellow.

Smooth surfaces such as hardboard (masonite) should first be lightly sanded to provide a key for the primer. Using a household paintbrush, apply two or three thin coats, each one at a right angle to the one before.

Allow each coat to dry before the next is applied.

TONED GROUNDS

A pure white canvas can be inhibiting to work on, especially for beginners. Most artists prefer to tone the ground with a thin layer of paint, in a neutral colour. Dilute the paint with turpentine or white spirit to a thin consistency and scrub it on

vigorously with a large flat brush or decorating brush. The toned ground must be completely dry before you start to paint on it.

PALETTE LAYOUT

It is said that if your palette is messy, your painting will be messy, so it is a good idea to get into the habit of laying out your colours in the same systematic

Priming Supports

1 Using a decorating brush, apply a smooth coat of primer and leave to dry.

2 Apply the second coat at right angles to the first to give a smooth, even surface.

SUGGESTED PALETTE

Cobalt Blue
Greener and paler than ultramarine blue, cobalt is good for skies and cool highlights in flesh tones.

Lemon Yellow
A transparent colour with a cool, pale yellow hue. It forms delicate, cool greens when mixed with blues.

French Ultramarine
This is the best general-purpose blue. A deep, warm blue, it mixes well with yellow to form a rich variety of greens and with earth colours to form colourful greys.

Cadmium Yellow
A bright, warm yellow with good covering power.

Cadmium Red
A warm, intense red. Produces good pinks and purples when mixed with blues.

Viridian
A bright, deep green with a bluish tinge. When squeezed from the tube it appears a "synthetic" green, but is wonderful in mixes.

Titanium White
A good, dense white that mixes well and has excellent covering power.

Cobalt Violet
Though you can make a violet with red and blue, it won't have the intensity of cobalt violet. A very expensive pigment, however.

Raw Sienna
A warm, transparent colour, very soft and subtle. Useful in landscapes.

Permanent Rose
A cool, pinkish red that is similar to alizarin crimson but not quite so overpowering in mixes. It is good for mixing pinks and purples.

Burnt Sienna
A rich, reddish-brown hue, useful for warming other colours. Mix it with ultramarine or viridian to make deep, rich dark tones.

Burnt Umber
A rich, opaque and versatile brown. Useful for darkening all colours.

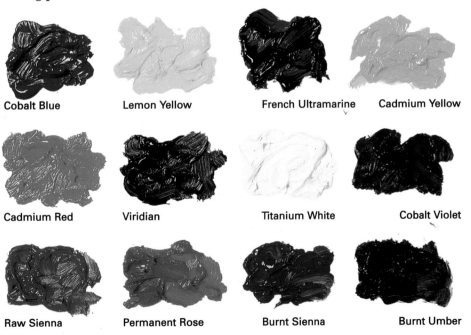

Cobalt Blue Lemon Yellow French Ultramarine Cadmium Yellow

Cadmium Red Viridian Titanium White Cobalt Violet

Raw Sienna Permanent Rose Burnt Sienna Burnt Umber

A wet oily surface can be difficult to work over. Use a piece of absorbent paper to blot off the excess paint, leaving a surface with more "grip".

order each time you paint. That way, you will automatically know where each colour is without having to search for it, and you will be able to concentrate on observing your subject. There are several systems for laying out colours. Some painters prefer to arrange their colours along one side of the palette in the order of the spectrum, with white and the earth colours on the other side; others use a light to dark or warm to cool sequence. Whatever system you choose, it's a good idea to put a large squeeze of white paint (used in most mixes) in the centre so the other colours can be easily combined with it.

HOLDING THE PALETTE

The traditional kidney-shaped palette has a bevelled thumb-hole for maximum comfort when painting at the easel. The curved indent at the leading edge allows you to grasp several brushes and your painting rag in one hand, while painting with the other. Hold the palette in your left hand (if you are right-handed), resting it on your forearm and fitting it up against your body.

MAKING CORRECTIONS

One of the advantages of painting in oils is that corrections can be made easily while the paint is still wet, or simply painted over when the paint is dry. An unsatisfactory passage can be removed while the paint is still fresh by scraping off the unwanted paint with a palette knife. This will leave a ghost of the original image and will form a helpful base on which to begin again. Alternatively, the scraped area can be completely removed with a rag soaked in turpentine.

If the canvas becomes clogged with thick paint and too slippery to work over, you can remove surface paint with absorbent paper, such as newspaper or tissue. Press the paper over the wet canvas and gently smooth it down with the flat of your hand, then carefully peel the paper away. The paper absorbs the excess oily paint,

At first when you try to hold your palette and everything else you may find it uncomfortable, but very soon it will become second nature.

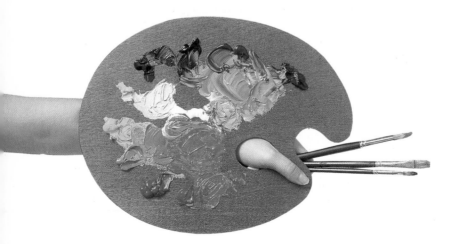

leaving a cleaner surface on which to work. This process is called "tonking" — named after Henry Tonks, a former professor of painting at the Slade School of Art in London.

PALETTES

Palettes come in a variety of shapes, sizes and materials. The best-quality palettes are made of mahogany ply, but fibre-board and melamine-faced palettes are adequate.

Thumbhole palettes are the most common type of palette, they come in various sizes and are designed to be held while painting at the easel. They have a thumbhole and indentation for the fingers, and the palette is supported on the forearm.

There are three main shapes: oblong, oval and the traditional kidney-shaped, or "studio" palette. For easel painting, the curved shape of the studio palette is the best choice as it is well balanced and comfort-able to hold for long periods of time.

Disposable palettes are made from oil-proof paper and are useful for outdoor work and for artists who hate cleaning up. They come in pads with tear-off sheets.

Improvised palettes can be made from any smooth, non-porous material, such as a sheet of white formica, a glass slab with white or neutral-coloured paper underneath, or a sheet of hardboard sealed with a coat of paint.

USING MEDIUMS AND DILUTENTS

Oil paint can be used thickly, direct from the tube but usually it needs to be diluted to make it easier to apply. Paint may be thinned to the required consistency with a dilutent such as distilled turpentine or white spirit, or a combination of a dilutent and an oil or varnish — what artists call a medium.

Dilutents

Paint mixed with a dilutent alone dries quickly to a matt finish. Always use double-distilled or rectified turpentine — ordinary household turpentine contains too, many impurities. If you find that it gives you a headache or irritates your skin, white spirit is a suitable alternative.

Even small quantities of solvents and thinners can be hazardous if not used with care, because their fumes are rapidly absorbed through the lungs. When using solvents, always work in a well-ventilated room and avoid inhalation. Do not eat, drink or smoke when you are working.

Mediums

Various oils and resins can be mixed with a dilutent to add texture and body to the paint. The most commonly used medium is a mixture of linseed oil and turpentine, usually in a ratio of 60% oil to 40% turpentine. Linseed oil dries to a glossy finish that is resistant to cracking — but be sure to buy

Use a mahl stick to steady your hand when painting details and fine lines. Place the padded end on a dry section of the painting or on the edge of the canvas. Then rest your painting arm on the stick.

either purified or cold-pressed linseed oil; boiled linseed oil contains impurities that cause rapid yellowing. Adding a little dammar varnish to the turpentine and linseed oil produces a thicker mixture that dries more quickly.

Ready-mixed painting mediums are available, designed variously to improve the flow of the paint, thicken it for impasto work, speed its drying rate, and produce a matt or a gloss finish.

PAINTING ACCESSORIES

Painting in oils can be very messy, so the most essential accessories are large jars or tins to hold solvents for cleaning brushes at the end of the day and a supply of cotton rags and newspaper for covering the surrounding area.

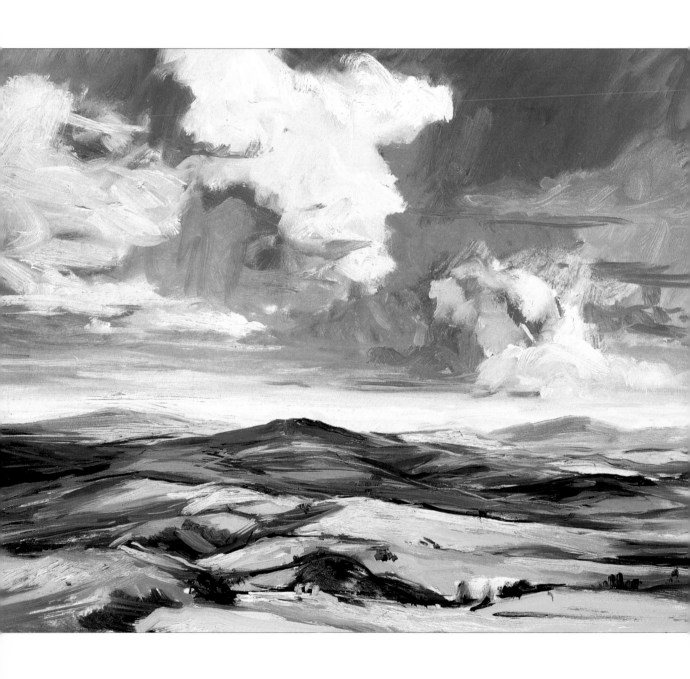

PAINTING "ALLA PRIMA"

This delightful and exuberant landscape was painted on-the-spot in the hills of Tuscany in southern Italy. In order to capture the movement of the scudding clouds and the rapidly changing light, the painting had to be executed quickly, in one sitting – a method known as "alla prima".

The artist started by blocking in the broad areas of the composition with thinned paint, which is easy to manipulate when working fast. He continued building up the colour, applying it in wide sweeps and rapid scumbles that give energy and movement to the scene.

When painting "alla prima" you have to be constantly aware of how the different elements of the image – line, mass, tone and colour – interact. To achieve balance and unity, the artist worked on all areas of the composition at once, rather than painting one area in detail before starting on the next; he kept his brush moving around the canvas, working from sky to land and back again, bringing all areas of the image to a similar level of detail at each stage.

David Carr
Tuscan Landscape
33 x 43cm (13 x 17in)

ALLA PRIMA TECHNIQUE

Alla prima is an Italian expression meaning "at the first", and describes a technique in which a painting is completed in one session, instead of being built up layer by layer. The French Impressionists and their forerunners – Constable (1776–1837) and Corot (1796–1875) – were great exponents of this method, which is particularly well suited to painting outdoors.

In *alla prima* painting there is generally little or no initial underpainting, although artists sometimes make a rapid underdrawing in charcoal or thinned paint to act as a guide. Each patch of colour is then laid down more or less as it will appear in the finished painting, or worked wet-into-wet with adjacent colours. The idea with this kind of painting is to capture the essence of the subject in an intuitive way, using vigorous, expressive brushstrokes and minimal colour mixing.

One of the great advantages of *alla prima* painting is that it creates an extremely stable paint surface. Whereas a painting that is composed of several built up layers may be prone to cracking eventually, due to the uneven drying rates of the different layers, a painting completed in one session dries uniformly, even when it is laid on thickly.

The ability to apply paint quickly and confidently is the key to the *alla prima* approach. It is, of course, always possible to scrape away and rework unsuccessful areas of a painting, but in doing so there is a danger that some of the freshness and spontaneity will be lost. It is therefore very important to start with a clear idea in your mind of what you want to convey in your painting, working with a limited palette can sometimes be a good idea, as you will not be tempted to include any unnecessary detail.

TUSCAN LANDSCAPE

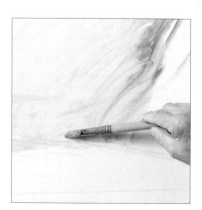

1

First establish the position of the horizon line, then work straight into the sky area. To create a warm base colour for the clouds, mix a soft yellow from yellow ochre and titanium white; for the patch of blue sky, use ultramarine and white. Dilute the paint thinly with a 50–50 mix of turpentine and linseed oil and apply it rapidly with broad, sweeping strokes, using the belly – not the tip – of a large round-bristle brush.

Materials and Equipment

• SHEET OF PRIMED CANVAS OR BOARD • OIL COLOURS: CADMIUM RED, CADMIUM YELLOW, CADMIUM LEMON, YELLOW OCHRE, COBALT GREEN, VIRIDIAN, FRENCH ULTRAMARINE, COBALT BLUE, CERULEAN, RAW UMBER, BURNT SIENNA AND TITANIUM WHITE • BRISTLE BRUSHES: LARGE AND SMALL ROUNDS, AND MEDIUM FILBERT • SMALL LETTERING BRUSH OR ROUND SOFT-HAIR BRUSH • TURPENTINE • LINSEED OIL • RAG AND WHITE SPIRIT FOR CLEANING

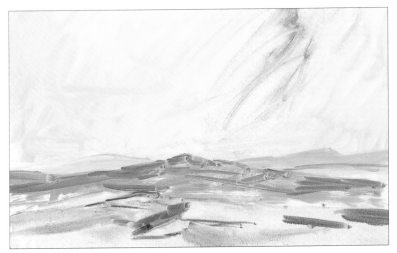

2

To enhance the mellow warmth of the Italian landscape, the greens and yellows of the hills and fields are underpainted in their complementary colours – reds and blues, respectively. Using a medium filbert brush, paint the most distant hills with a thin wash of pale pink mixed from cadmium red, white and a touch of cadmium yellow. Strengthen the mix with more red and less white for the nearer hills. Underpaint the wheat fields with cobalt blue, then map in the dark trees and hedges with a mix of burnt sienna and cadmium red.

3

With a thin mix of ultramarine and white, block in the patches of blue sky and roughly outline the masses of cumulus cloud. Again, use the flattened belly of the bristle head to make broad, energetic strokes, letting the brush marks convey a sense of movement.

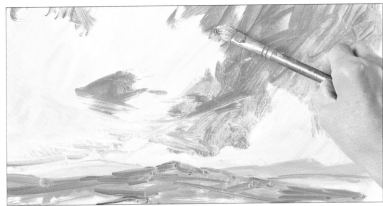

4

Now work on the distant sky and hills to create a sense of the land and sky disappearing over the horizon. Mix a cool, soft green from cobalt green and white. Drag this over the furthest hills, letting the pink undercolour show through the green. Then mix a soft pinkish yellow from cadmium yellow, white and a touch of cadmium red and paint a narrow band of this right along the horizon line, just above the hills, to create the effect of misty light in the distance.

With a small round brush, mix a dark green from viridian and yellow ochre and define the trees and hedgerows between the fields, dragging the paint on with the side of the brush.

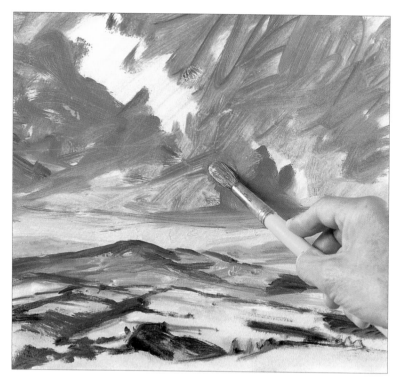

5

Mix ultramarine and white, then add touches of burnt sienna and yellow ochre until you have a warm grey. Paint the shadow sides of the clouds with a large round brush, scrubbing the paint on with vigorous brushmarks that give a sense of movement. Always remember to keep your cloud shadows consistent with the direction of the light – here the sun is at the top right, so the cloud shadows are on the left of the cloud masses.

6

Paint the patchwork of wheatfields using a medium filbert brush and varied mixtures of cadmium yellow and yellow ochre, plus cadmium lemon for the brightly lit fields. With a large round brush, paint the lit areas of cloud by working into the grey clouds with a warm, creamy white mixed from white, cadmium yellow, cadmium red and yellow ochre. Use slightly thicker paint and scrubby, scumbled strokes to create the effect of towering heaps of cloud, particularly in the foreground. As the clouds recede into the distance, use flatter strokes.

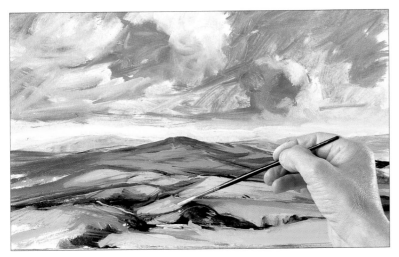

7

Neutralize the yellow mixes with some grey mixed earlier and, with a medium filbert brush, darken areas where the clouds cast shadows onto the land. Add definition to fields and hedgerows using paint that is fluid, but with body. (Here a sable lettering brush, which is round but with a flat point and long bristles is used to give smooth, fluid lines. If you don't have one, a small round soft-hair brush will do.) For the hedgerows, use a dark mix of viridian, ultramarine and raw umber. Bring the nearest fields forward with mixtures of cadmium red, yellow and lemon.

8

The sky appears paler and cooler as it recedes towards the horizon. To recreate this effect, mix three shades of blue on your palette and then blend them together on the canvas with a medium filbert brush so that they merge gently into one another. Start at the top with ultramarine and white, then introduce cerulean and white as you work downwards. Near the horizon, use white with hints of cadmium yellow and red added.

Scumble a mixture of white and a hint of yellow ochre onto the sunlit tops of the clouds with rough, scrubby marks.

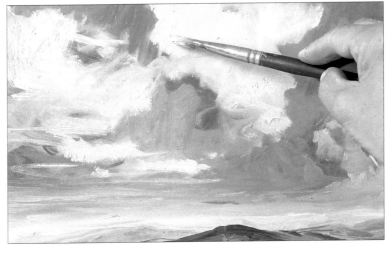

9

Finally, tie the painting together by echoing some of the sky colours in the land below, adding touches of ultramarine and white, and yellow ochre and white to the fields. Strengthen the shadows on the fields with dark greens. Try not to overwork the painting – keep it fresh and lively. If the paint becomes too opaque and dense, you can scratch into it with the end of a paintbrush to reclaim the colour of the underpainting, as shown here.

USING A TONED GROUND

There are times when it is appropriate to paint directly onto a white canvas, but most oil painters prefer to tint the ground with a colour that sets a key for the painting. In this interior scene small patches of the umber ground remain exposed throughout the picture, their neutral colour helping to unify the composition and enhancing the impression of soft, cool light penetrating the room from the window behind.

It is important that the toned ground is completely dry before you paint over it. An oil ground usually takes around 24 hours to dry thoroughly, but you can save time by using acrylic paint instead. This dries in minutes, allowing you to overpaint in oils straight away. The other great advantage is that acrylic paint acts as both a sealing agent and a primer, so you don't need to size and prime the support as you would for oils. (Never apply acrylics on a ground that has been sized and primed for oils, however, as this may lead to eventual cracking of the paint film.)

James Horton
French Interior
25 x 18cm (10 x 7in)

TONING THE GROUND

A primed white ground can be rather intimidating to begin painting on and can also give you a false "reading" of the colours and tones you apply, especially in the early stages when you've no other colours to relate them to. The way to avoid this problem is by toning the ground with a wash of neutral colour prior to painting.

A toned ground provides a more sympathetic surface to work on, acting as a unifying mid-tone against which you can judge your lights and darks more accurately. Generally it is best to choose a subtle, muted colour somewhere between the lightest and the darkest colours in the painting. Diluted earth colours such as Venetian red, raw sienna or burnt umber work very well,

as do soft greys and greens. Some artists prefer to begin with a ground that will harmonize with the dominant colour of the subject; for instance, a soft pink or yellow ground for an evening sky. Others prefer a ground that provides a quiet contrast, such as a warm red-brown that will enhance the greens used in a landscape.

To tone the ground, dilute the paint to a thin, "orange juice" consistency with turpentine or white (mineral) spirit and apply it freely and vigorously over the white priming with a household decorating brush or a rag soaked in turpentine. If you prefer a smooth, more regular effect, work over the wet paint with a damp, lint-free rag to even out the brushmarks.

FRENCH INTERIOR

1

Prepare the toned ground about 24 hours in advance – it must be thoroughly dry before starting to paint. Mix raw umber with a little French ultramarine and dilute it to a thin consistency with turpentine. Apply this all over the board using a 25mm (1in) decorating brush.

Sketch in the main outlines of the composition using thinly diluted French ultramarine and a small sable brush.

Materials and Equipment

• SHEET OF PRIMED HARDBOARD OR MDF • OIL COLOURS: CADMIUM RED, ALIZARIN CRIMSON, VERMILION, CADMIUM ORANGE, CADMIUM YELLOW, YELLOW OCHRE, LEMON YELLOW, TERRE VERTE, FRENCH ULTRAMARINE, COBALT BLUE, RAW UMBER, BURNT SIENNA, TITANIUM WHITE AND IVORY BLACK • 25MM (1IN) DECORATING BRUSH • OIL-PAINTING BRUSHES: SMALL SABLE OR SYNTHETIC, MEDIUM-SIZED ROUND BRISTLE, SMALL ROUND BRISTLE, SABLE OR SYNTHETIC RIGGER • PURE LINSEED OIL • DAMMAR VARNISH • DISTILLED TURPENTINE

2

From this point, mix your colours with a medium consisting of linseed oil, dammar varnish and turpentine. Using a medium size round bristle brush, rough in the walls around the open doorway with a warm brown mixed from burnt sienna, raw umber and titanium white. Vary the proportions of these colours and add touches of lemon yellow and terre verte to create subtle shifts in tone and temperature. Don't apply the paint in a flat wash but scuff it on with broken strokes, letting the ground colour show through.

3

Use the same colour and the same technique to paint the curtains at the window. Start to block in the wall around the window using loose strokes of ultramarine greyed with a little yellow ochre, interspersed with strokes of greenish grey mixed from raw umber and yellow ochre. Use a smaller round brush to paint the bright reflection on the ceiling with white and a mix of cobalt blue, alizarin crimson and white. For the pink strip at the top of the window, mix vermilion and white.

4

Now paint the view glimpsed through the window. Mix white and a tiny drop of alizarin crimson for the sky, then suggest the trees with varied mixtures of lemon yellow, terre verte, cobalt blue and white. Use a greater proportion of blue and green for the darker tones and more yellow and white for the lighter tones. Paint the window frame with raw umber and the sill with cobalt blue, alizarin crimson and white.

5

Add more colour to the curtains with strokes of raw umber and white. Loosely paint the chair back with a mix of French ultramarine, yellow ochre and a little ivory black. Then suggest the reflective surface of the floor using mainly white, broken with a little burnt sienna and alizarin crimson. Apply the colour in loose patches, letting the ground colour form the mid-tone.

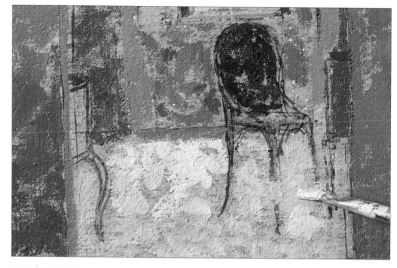

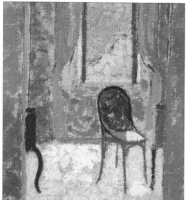

6

Paint the pieces of furniture glimpsed through the doorway, using black, cadmium red and alizarin crimson for the dark wood and burnt sienna and raw umber for the lighter wood of the chair legs. For the chair seat, mix white, ultramarine and alizarin. Use the same mixture used on the back, lightened with more white, for the shadow on the chair seat.

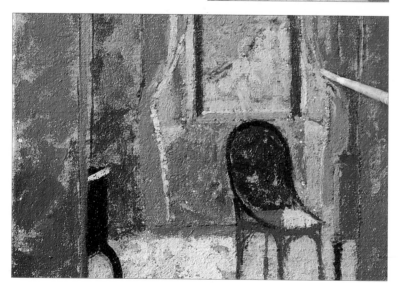

7

Lighten the tone of the wall beneath the window with a warm grey mixed from ultramarine, yellow ochre, white and a hint of black, loosely applied over the underlayer of brown. Block in the base of the shutters with vermilion and white, then add warm highlights on the curtains where the light shines through the fabric, using a small round brush and mixtures of cadmium orange, cadmium yellow and white.

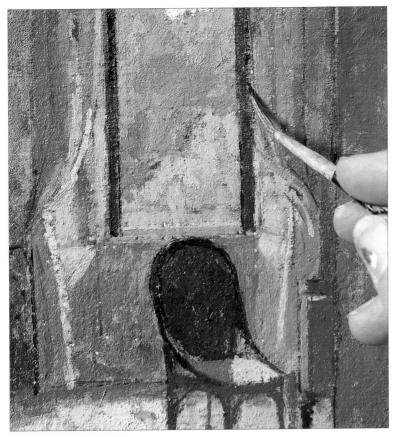

8

Now that the close tones of the interior are established, you can adjust the brighter tones of the sunlit view outside to the correct pitch. Here the greens of the hills and trees need to be lighter and cooler to push them back in space. Mix cobalt, alizarin and white for the distant hills, then block in the medium-toned foliage with varied mixtures of white, lemon yellow, terre verte and a hint of cobalt blue. Use a rigger brush, which has long, flexible hairs, to define the edge of the window frame with a very thin line of black.

9

Finally, mix a sludgy grey from raw umber, ultramarine, burnt sienna and yellow ochre and use this to paint the shadows cast by the furniture legs on the shiny floor. Use the rigger brush again, applying the paint with slightly wavering strokes.

Technique

14

SCUMBLING

One of the most beautiful effects in oil painting, scumbling involves brushing thin, dry paint over another layer of colour with a rapid scrubbing motion. Because the colour is applied unevenly the underlayer is only partially obscured and shimmers up through the scumble, creating an "optical" colour mix with extraordinary depth and richness. Scumbling also produces a lively, unpredictable texture in which the marks of the brush are evident.

The technique is used to good effect in this painting to capture the shimmer and the reflective quality of a beach at low tide when viewed directly into the setting sun. The artist worked over the whole canvas with thin veils of stiff, chalky paint scumbled and dragged over a red ground. The warm tone of the ground glows up through the overlaid colours, capturing the pearly, luminous quality that is characteristic of early evening light on the coast.

Barry Freeman
Evening Sun, Portugal
41 x 51cm (16 x 20in)

SCUMBLING

A scumble consists of short, scrubby strokes of thin, dry, semi-opaque colour applied loosely over previous layers of the painting. Because the colour is applied unevenly the underlayer is only partially obscured and shimmers up through the scumble. The interaction between the two layers creates a pleasing effect – the colours mix optically and have more resonance.

Scumbling is also a good way to modify an exisiting colour. A red that is too strident can be subtly "knocked back" by scumbling over it with a cool green, and vice versa. Similarly, passages that have become too "jumpy" and fragmented can be softened and unified by working over them with scumbled colour.

Use stiff bristle or synthetic brushes for scumbling. Pick up some paint on your brush, then flick it across a rag to remove excess moisture. Lightly scrub the paint on with free, vigorous strokes, leaving the brushmarks. The aim is to produce a semi-transparent overlayer, like a haze of smoke, through which the underlayers can be glimpsed. The paint can be worked in various directions. You can also scumble with a rag or a painting knife.

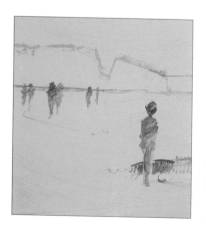

It is important to build up scumbles thinly, in gradual stages. If the paint is applied too heavily, the hazy, veil-like effect will be lost.

EVENING SUN, PORTUGAL

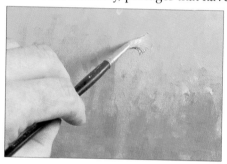

1

Prepare your board by tinting it with a thin, turpsy wash consisting of roughly 70% cadmium red and 30% cerulean. Apply this with a small decorating brush, then wipe over the wet paint with a clean rag to unify the surface. Leave to dry overnight.

Sketch in the main elements of the composition with a small round soft-hair brush, using varied tones of French ultramarine and cadmium red. Indicate the figures with brief, sketchy marks at this stage.

Materials and Equipment

• SHEET OF PRIMED MDF BOARD
• OIL COLOURS: CADMIUM RED, ROSE MADDER, ALIZARIN CRIMSON, CADMIUM LEMON, CADMIUM YELLOW, FRENCH ULTRAMARINE, COBALT BLUE, CERULEAN AND TITANIUM WHITE
• SMALL ROUND SOFT-HAIR BRUSH • MEDIUM ROUND SYNTHETIC BRUSH • SMALL DECORATING BRUSH • LINT-FREE RAG • DISTILLED TURPENTINE
• PURE LINSEED OIL

2

Mix the paint with a little oil-painting medium to give it more body. Don't add too much though – paint for scumbling should be fairly "dry" in consistency. Block in the sky using titanium white "dirtied" with small amounts of cadmium red, cobalt blue and a touch of cadmium yellow. Apply the scumbling paint with lively strokes worked in different directions, using a medium-size, round synthetic brush.

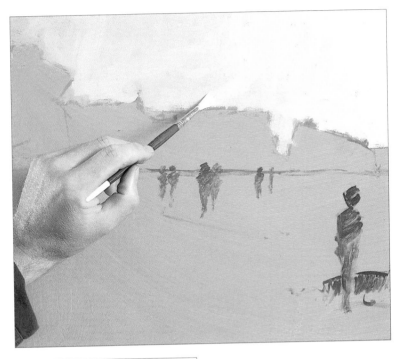

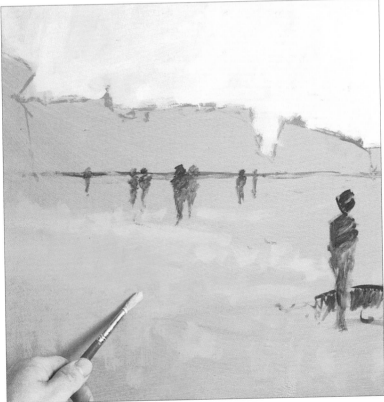

3

Now darken the mixture with more cadmium red and a touch of alizarin crimson and start to paint the sand in the foreground. Apply the paint with loose, scrubby strokes, letting plenty of the warm red of the tinted ground to show through. Modulate the tone and temperature of the sand colour as you work, adding more cobalt to cool the mix, or more cadmium yellow to warm it.

4

Add French ultramarine, plus more cadmium red and cadmium yellow to the mix on the palette to make a dark grey. Paint the cliffs in the background, again modulating the colour from warm to cool by adding more blue or more yellow to the basic mix. Work your brush in different directions to suggest the craggy surface of the cliffs.

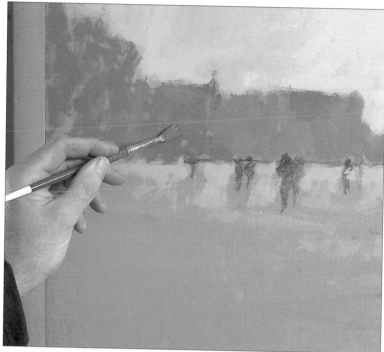

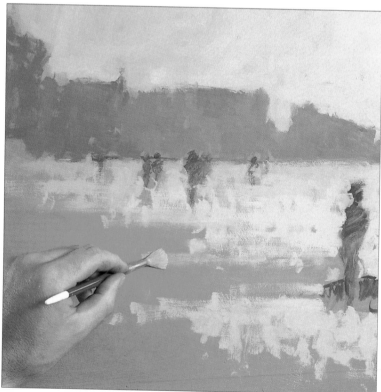

5

Lighten the grey mixture with more cobalt blue and titanium white to make a cooler, lighter grey for the headland glimpsed on the right, in the far distance. Now lighten the mix even more, adding plenty of white plus hints of rose madder and cadmium yellow to make a silvery grey. Use this to paint the sea and the rock pool in the foreground, scumbling the paint on loosely with small brushmarks worked in horizontal and vertical directions. Where the shallow water meets the sand, use a thirsty brush and dryish paint, dragging it lightly across so that the strokes break up on the rough surface of the canvas.

6

Mix a soft, neutral tint of cadmium red, cadmium lemon, a little cobalt blue and lots of titanium white. Apply this with lightly scumbled strokes to soften the edge where the water and sand meet and link them naturally together. Then mix varied amounts of cobalt blue, cadmium red and white and paint the cast shadow in the foreground and the rock on the right, letting flecks of the toned ground show through the scumbled strokes.

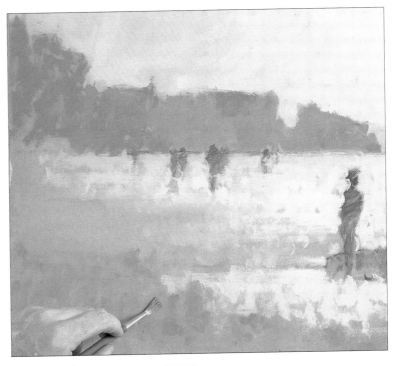

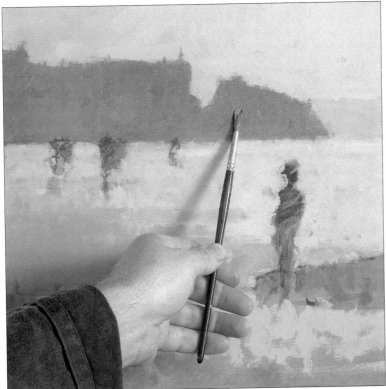

7

Build up more colour on the cliffs, mixing varied tones of ultramarine, cadmium red and touches of cadmium yellow and white for the dark cliff on the left. Work over the lighter cliffs with varied tones of rose madder, cobalt blue and cadmium yellow mixed in varied proportions. Scuff the paint on lightly so that some of the pink ground glows through and lends a luminosity to the colours.

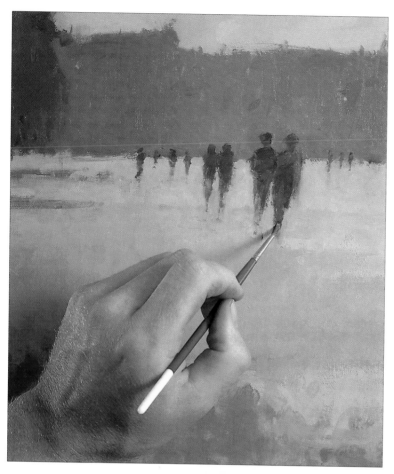

8

Switch to a small round soft-hair brush and define the figures on the beach using a soft, bluish grey mixed from ultramarine, rose madder and a bit of cadmium yellow. Use the tip of the brush to suggest tiny figures in the distance, beneath the cliffs. The figures should not be too dark as the evening light is soft and hazy.

9

Avoid defining the figures too sharply and making them appear wooden and "pasted on" to the picture. Here the artist has "lost" edges on the figures by smudging the paint. By lightly dragging the colour down from the base of each figure, he also suggests their reflections on the wet sand.

10

Stand back from your painting – or even take a break from it – so you can assess any modifications that need to be made before continuing. Here, for example, the artist realized that the figures form a straight line going into the distance, so he added two more figures, a little to the right, to break the monotony. He also altered the shape of one of the figures, which was too heavy and square. Finally, he warmed the colour of the distant figures with a mix of cadmium red and cobalt blue, and added highlights using white mixed with cobalt blue and a little alizarin.

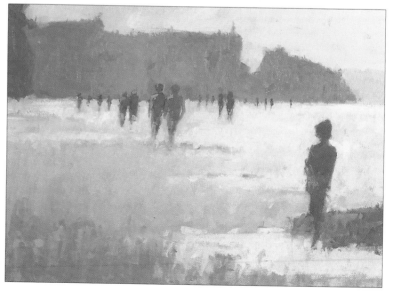

11

Build up the tones on the sand with varied mixes of white, cadmium lemon, cadmium yellow and a hint of alizarin. Then paint the seaweed-covered rocks in the foreground using scumbled strokes. Start with a violet mix of cadmium red and cobalt blue, then mix cobalt, cadmium yellow and a little cadmium red for the seaweed. Add French ultramarine to the mix for the darker greens, and more yellow and white for the lighter greens on the top of the rock. Lighten the mixes with white to paint the rocks and seaweed in the background.

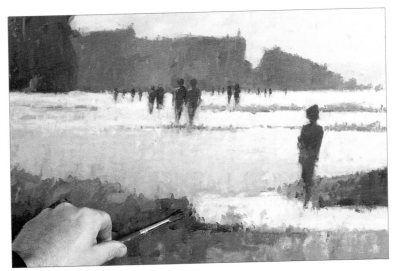

12

Mix a warm grey with cobalt blue, white and a touch of alizarin and use this to grey down the water in the rock pool. Darken the mix and suggest the figure's reflection in the water. Then mix cadmium red, cadmium yellow and a touch of cobalt and scumble this over the sand in the immediate foreground to deepen its tone and bring it forward.

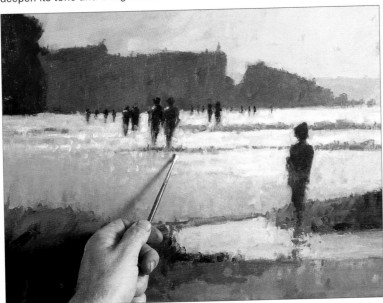

13

Step back and assess your painting once more, and make any final adjustments to the tones and colours. Use a small round brush to scumble on the sparkling highlights on the water using white tinted with a hint of rose madder and ultramarine. To complete the painting, mix white with cadmium red and yellow and add tiny highlights on the shoulders of some of the background figures lit by the setting sun.

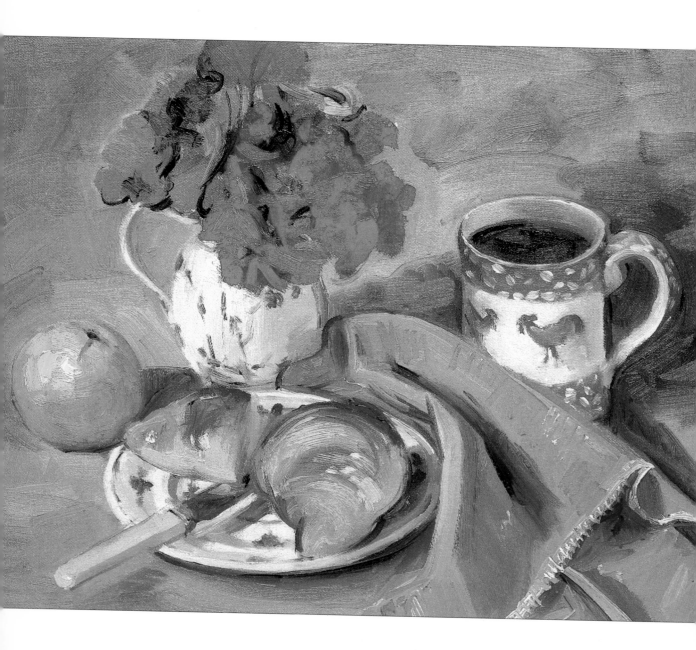

UNDERPAINTING

Many painters like to start a complex oil painting by brushing in the broad areas of the composition in thin colour in order to help them organize the picture in terms of shapes and tones.

Making an underpainting is, in effect, a way of "starting before you've begun". The intimidating white of the canvas is quickly covered, and at a very early stage the picture already reads as a whole. The underpainting may be completely covered as the picture is built up, or it can play an active role in the final painting if parts of it are left visible. This creates a pleasing contrast between thin and thick applications of paint, as well as breathing air into the painting and injecting a lively, working feel.

Underpainting is traditionally done in a monochrome grey or earth colour, which acts as a guide for the light and dark tones in the image. In this painting, however, the artist chose to underpaint in light colours approximating those of the subject. Thus the succeeding colours, as well as tones, are more easily judged against the underpainting.

Ted Gould
Coffee and Croissant
36 x 46cm (14 x 18in)

UNDERPAINTING

The traditional way of starting an oil painting is to block in the broad shapes and masses with thin paint before adding the details and surface colour. The underpainting gives you the opportunity to organize the composition and the distribution of light and dark values at the outset, and to resolve any problems before starting to paint. Because the paint is thin, corrections are easily made at this stage by wiping with a rag.

The result is a practical division of labour; once the underpainting is complete you can concentrate on colour and detail, confident that the composition and tonal values are sound.

Traditionally, neutral greys, blues or earth colours are used to underpaint. The darks and mid-tones are established with tones of one colour, leaving the white or tinted canvas to act as the highlights. Underpainting may also be done in colours that either complement or contrast with the overall colour values of the subject. For example, an underpainting in warm browns or reds will give resonance to the cool greens of a landscape. The underpainting can also be laid in several colours that relate to those used in the final painting.

Colours for underpainting should be thinly diluted with turpentine or white (mineral) spirit. The underpainting must also be thoroughly dry before you start the overpainting. To save time, you can underpaint with acrylic colours (thinly diluted with water) and then overpaint in oils. Acrylics dry within minutes, allowing you to apply the next layer in oil almost immediately.

COFFEE AND CROISSANT

Left: A pretty and informal breakfast setting is the subject of this still life. Although the objects appear casually arranged, they are in fact carefully composed to create a strong, cohesive group.

1 Start by drawing the main outlines using acrylics. Mix yellow ochre with a touch of French ultramarine and dilute with water to a thin consistency. Sketch loosely with a small round synthetic brush. Horizontal and vertical axes lines will help you to draw the round and elliptical shapes accurately. Leave to dry – this will take only a few minutes.

Materials and Equipment

- SHEET OF CANVAS OR BOARD
- ACRYLIC COLOURS: BRIGHT RED, CRIMSON, LEMON YELLOW YELLOW OCHRE, BRIGHT GREEN, FRENCH ULTRAMARINE AND BURNT SIENNA • OIL COLOURS: INDIAN RED, VENETIAN RED, SCARLET LAKE, ALIZARIN CRIMSON, YELLOW OCHRE, WINSOR YELLOW, WINSOR GREEN, FRENCH ULTRAMARINE AND TITANIUM WHITE • SMALL ROUND SYNTHETIC BRUSH
- SMALL, MEDIUM AND LARGE FLAT BRISTLE BRUSHES
- TURPENTINE • LINSEED OIL
- JAR OF WATER

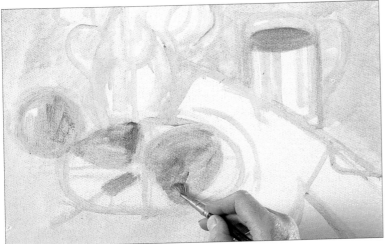

2

Now establish the underpainting, again using fast-drying acrylic paints. Mix a thin, watery wash of yellow ochre warmed with a little burnt sienna, and use a large flat synthetic brush to loosely block in the background. Darken the mix with ultramarine and touch in the coffee in the mug using a medium-sized flat brush. Mix yellow ochre and bright red for the orange, then add a touch of burnt sienna to the mix and block in the split croissant and the knife blade. Work thinly and rapidly, not worrying about details at this stage.

3

Continue underpainting with colours approximating those of the actual objects. Use very thinly diluted crimson for the napkin, darkened with ultramarine for the shadows and creases. Block in the geranium flowers with crimson mixed with lemon yellow for the warmer reds and ultramarine for the cooler, darker reds. Use bright green for the geranium leaves, adding lemon yellow for the warmer greens and ultramarine for the cooler greens. Paint the blue cockerel pattern on the mug with ultramarine, then add burnt sienna for the cast shadows.

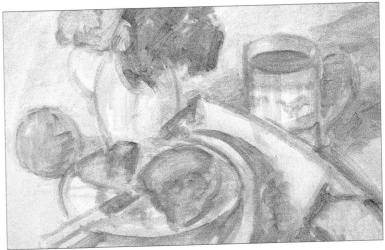

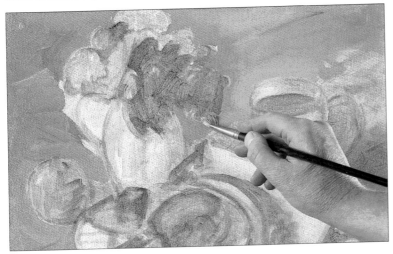

4

Once the acrylic underpainting is dry you can start to overpaint in oils, thinning the colours with turpentine and linseed oil medium. First, block in the background with loosely mixed Indian red, yellow ochre, Winsor yellow and titanium white. Use a large flat bristle brush and sweep the paint on quite vigorously, working the brush in different directions and letting the marks of the brush show. Paint up to the still-life forms, then cut into them to begin to define them.

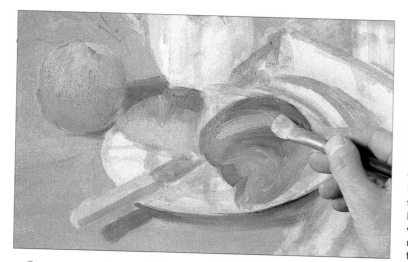

5

Use a medium-sized flat brush to define the orange with Winsor yellow and Indian red, adding more yellow for the light tones on top and more red for the shadows. For the deeper shadow near the base, darken with a little alizarin. Mix yellow ochre, white and a touch of ultramarine for the knife handle. Paint the shadows on the table with a mix of yellow ochre, Indian red and ultramarine. Define the croissant halves using Indian red broken with yellow ochre, Winsor yellow and white. Add more Indian red for the crusty tops. Follow the forms with your brushstrokes.

6

Paint the coffee in the mug with a mix of Indian red, ultramarine and yellow ochre. Mix a warm grey from ultramarine, yellow ochre and a touch of Indian red and put in the shadows on the plate and the blade of the knife. Define the flower jug with pale greys mixed from ultramarine, yellow ochre, a touch of Indian red and plenty of white. Create different subtle tones, adding more blue for the shadows on the jug. Mix alizarin and Winsor yellow and block in the geraniums with strokes in different directions. Add ultramarine for darker reds.

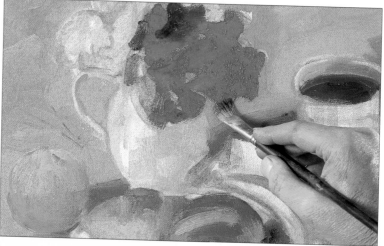

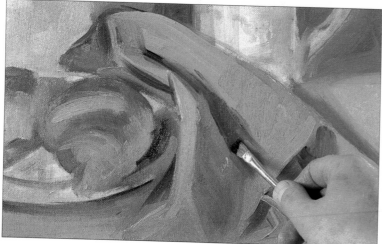

7

Now work on the pink napkin, first blocking in the local colour with a medium-toned mix of alizarin crimson, white and a touch of ultramarine. Then define the creases and folds with thick, creamy paint applied with a small flat brush. Mix alizarin crimson and ultramarine for the shadowy folds, and white with a touch of alizarin for the highlights along the tops of the folds.

8

Return to the geranium flowers and start to define the petals with short strokes of thick, juicy paint, letting the individual brushstrokes form the shapes of the petals. Mix some scarlet lake and a touch of titanium white for the lightest petals, and alizarin crimson and ultramarine for the darker, cooler petals. Add touches of Venetian red for the warm shadows between the blooms.

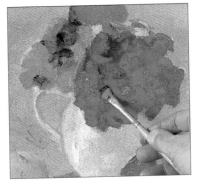

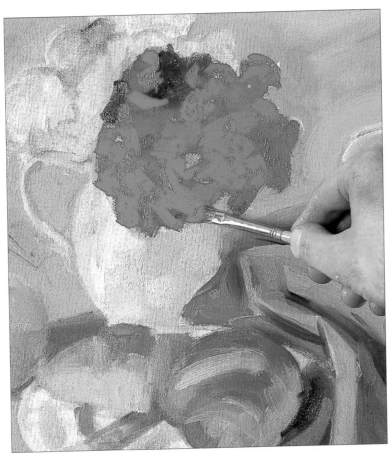

9

Now paint the geranium leaves in the same way, pivoting from the wrist to follow their curved forms with blocks of colour and tone. Use pure Winsor green for the darkest tones, adding Winsor yellow for the bright greens and a touch of yellow ochre for the warm mid-tones. Cut into the flowers with small strokes of green to indicate the gaps between the blooms.

10

Refine the tones on the jug and plate with smooth strokes of white, broken with hints of alizarin and ultramarine blended into the greys applied earlier. Suggest the napkin's reflection on the jug with a hint of alizarin and white. Define the blue and white pattern on the coffee mug with ultramarine and white.

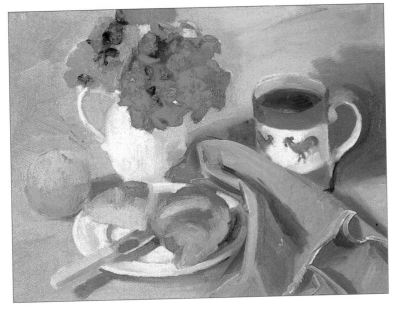

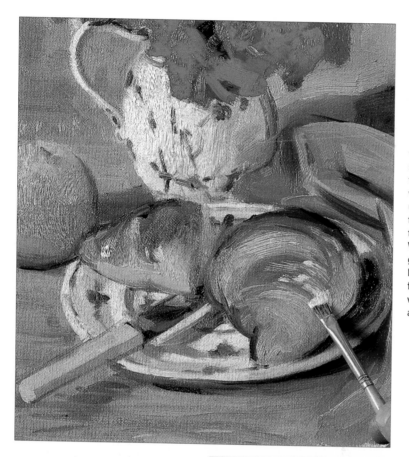

11

Mix ultramarine with a hint of Indian red and paint the decorative blue pattern on the jug and plate with the tip of a small round soft-hair brush. Paint the reflections on the knife blade with strokes of ultramarine, Indian red and yellow ochre. Switch to a small flat bristle brush and suggest the grain of the wooden table with loose drybrush strokes of white and yellow ochre mixed with ultramarine and Indian red. Enrich the colours on the croissant with thick strokes of Indian red and Winsor yellow. Then use white greyed with hints of ultramarine and Indian red to suggest the sugar-frosting on the top of the croissant with feathery strokes of thick paint applied with a thirsty brush.

12

Develop light and shade on the orange with thickly impasted strokes of alizarin crimson, Winsor yellow, white and a touch of scarlet lake, with more yellow ochre for the greenish shadow on the right. Paint the dimple with ultramarine and Indian red, and add the bright highlights with thick dabs of pure white. Mix ultramarine, Indian red and yellow ochre for the dark shadows on the surface of the coffee. Finally, add more texture and movement in the background with loose mixtures of Indian red, yellow ochre, Winsor yellow and white applied with vigorous strokes of creamy paint.

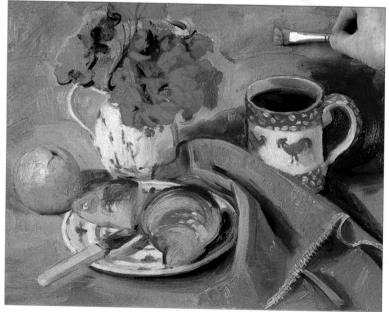

SUPPLIERS

UNITED KINGDOM

Art Base
88 North Street
Hornchurch
Essex RM11 1SR
(general art suppliers)

Daler-Rowney Ltd
12 Percy Street
London W1A 9BP
Tel: 0171 636 8241
(painting and drawing materials)

John Mathieson & Co
48 Frederick Street
Edinburgh EH2 1HG
Tel: 0131 225 6798
(general art supplies)

Reeves
178 Kensington High Street
London
W8 7NX
Tel: 0171 937 5370
(painting and drawing materials)

Stuart R Stevenson
68 Clerkenwell Road
London
EC1M 5QA
Tel: 0171 253 1693

SOUTH AFRICA

Art & Craft & Hobbies
72 Hibernia Street
P. O. Box 9635
George 6530
Tel: (0441) 74 1337
(Also offers all-hours nationwide
mail-order service)

Art Supplies
16 Ameshof Street
Braamfontein
Gauteng
Tel: (011) 339 2268

The Artist's Friend
Russel House, 41 Sir Lowry Road
Cape Town
Tel: (021) 45 4027 Fax: (021) 461 2901

Herbert Evans Art Shop
Cnr Nugget and Jeppe Streets
Johannesburg
Tel: (011) 402 2040

In-Fin-Art
9 Wolfe Street
Wynberg Cape Town
Tel: (021) 761 2816 Fax: (021) 761 1884

PW Story
18 Foundry Lane
Durban
Tel: (031) 306 1224

Shop 148
The Pavilion
Westville
Tel: (031) 265 0250

AUSTRALIA

Art Stretchers Co Pty Ltd
188 Morphett Street
Adelaide, South Australia 5000
Tel: (08) 212 2711

Artiscare
101 York Street
South Melbourne, Victoria 33205
Tel: (03) 9699 6188

Creative Hot Shop
96b Beaufort Street
Perth, Western Australia 6000
Tel: (08) 328 5437

Eckersley's
Cnr Edward and Mary Streets
Brisbane, Queensland 4000
Tel: (07) 3221 4866

Oxford Art Supplies
221–223 Oxford Street
Darlinghurst NSW 2010
Tel: (02) 360 4066

NEW ZEALAND

Draw-Art Supplies Ltd
5 Mahunga Drive
Mangere
Tel: (09) 636 4862

The French Art Shop
51 Ponsonby Road
Ponsonby
Tel: (09) 379 4976

Gordon Harris
Art & Drawing Office Supplies
4 Gillies Avenue
Newmarket
Tel: (09) 520 4466

Studio Art Supplies (Parnell) Ltd
225 Parnell Road
Parnell
Tel: (09) 377 0302

Takapuna Art Supplies
18 Northcroft Street
Takapuna
Tel: (09) 489 7213

UNITED STATES

Art Supply Warehouse
360 Main Avenue
Norwalk
CT 06851
Tel: (800) 243 5038
(general art supplies – mail order)

Creative Materials Catalog
P. O. Box 1267
Gatesburg
IL 61401
Tel: (800) 447 8192
(general art supplies – mail order)

Hofcraft
P. O. Box 1791
Grand Rapids
MI 49501
Tel: (800) 435 7554
(general art supplies – mail order)

Pearl Paints
308 Canal Street
New York
NY 10013 2572
Tel: (800) 415 7327
(general art supplies – mail order)

INDEX

PICTURE CREDITS
The author and publishers would like to thank the following for permission to reproduce additional photographs:

Visual Arts Library: pages 5, 6 Tate Gallery/Whaam!, 1963, © Roy Lichtenstein/DACS 1994, 7 (Chicago Arts Institute)